CW00503936

Painting in Earnest - the story of artist
**Ernest Stafford Carlos set in the context of South
London and his family roots**

ISBN 978-0-9926197-0-1

Published 2013 by Lewarne Publishing

PO Box 26946
London SE21 8XG

www.lewarnepublishing.co.uk

Typeset, printed and bound by Catford Print, London SE6 2PN

Image on front cover: *The Pathfinder* window in St. Mary's Church, Roch, Pembrokeshire (the window is in the style of William Morris). It was installed there in memory of brothers Captains Colwyn and Roland Philipps, who were killed while serving their country during the First World War. The placement of the window and choice of design were the inspiration of their father, Viscount St. Davids. It also includes arrow tracking signs and - a circle of stones with one at its centre - the 'Gone Home' sign.

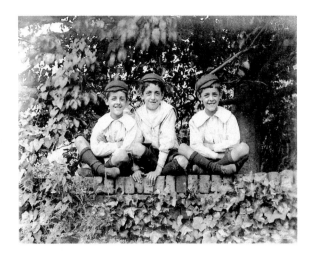

Young Ernest seated between his twin brothers.

The artist's self-portrait.

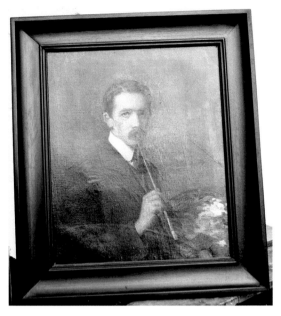

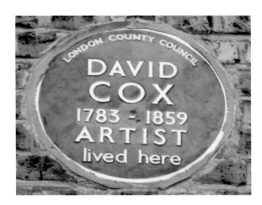

Left and below: the blue plaque denotes pre-Carlos times; and Foxley Road looking towards Vassall Road. Cox lived around fourteen years in Lambeth (he also resided in nearby Dulwich for a while), where he taught drawing and gained commissions from the aristocracy of the West End (visiting their homes). He was later able to charge a guinea a lesson.

The Regency style homes in Foxley Road were built *c.* 1824.

Foreword by Bear Grylls,
Survival Expert, Adventurer and Chief Scout

Scouting is full of brilliant, talented people who light up the lives of others. These are the kinds of selfless, cheerful people who inspire young people the most and who remind us why we are involved in this great movement in the first place.

The painter Ernest Stafford Carlos was one of these people. A painter of rare ability and member of the Royal Academy, he lost his life early, like so many others of his generation, in the First World War. But this was not before leaving a legacy as an artist, youth leader and social activist which survives to this day - which earned him a reputation of being 'the Scout painter'.

His works are both idealistic and realistic. On the one hand, he captures the naturalistic pose of a Scout relaxing in a tent while listening to a yarn told by another Scout (as in *A Ripping Yarn*). In another painting he perfectly captures the wonder and optimism of young people - take, for example, his *Day Dreams* where an older boy looks out of a window in a dark room towards a bright future.

Most of all, he shows young Scouts as independently minded, determined and committed. Often they are depicted as examples to adults (rather than the other way around) as the true way to live your life - helping others and spending time with friends, working together.

In *Good service work in a London slum* and *The Pathfinder* (both *c*. 1913) he makes a case for Scouting as a force for good, helping make life better for young people, and others in local communities - something Scouting still does to this day.

I've seen Carlos's pictures myself at Gilwell Park, the home of Scouting. Standing in front of them I am struck by the way they make the past come to life – and continue to inspire Scouts as the active citizens of the future.

Steven Harris has written Carlos's moving story with an impressive clarity (I read it in one sitting) and with great attention to detail (Ernest was not beneath painting portraits of dogs to earn a living!). He knows well the area in South London where Carlos grew up and knows Scouting equally well. In this, the first biography of the man, he has done his memory a great service.

I am not the first Chief Scout to write about Ernest - Baden-Powell (also an artist, and one who even had a sculpture exhibited at the Royal Academy) himself wrote to his mother: 'I am certain that his pictures and especially *The Pathfinder* have already done an immense amount of good … and will live to do more.'

In one of his last letters home from the Front, Ernest wrote 'I hope after the war to get back again to some of my so called slum work.' Like Baden-Powell and millions of other Scouts worldwide, he helped other people and thought of others before himself.

CONTENTS

INTRODUCTION page 5

ERNEST'S ANCESTORS page 9

ERNEST'S GRANDPARENTS page 15

THE ROOTS OF ERNEST'S ARTISTIC TALENT page 19

HARD TIMES, AS DICKENS WOULD SAY page 23

WHAT WAS TO BE DONE WITH THE ELDEST BOY? page 25

HELP FROM THE ROYAL LITERARY FUND page 27

A NORTH OF THE THAMES INTERLUDE page 29

THE PARENTS AND SIBLINGS OF THE FUTURE ARTIST page 31

A MOVE TO 42 FOXLEY ROAD AND ERNEST'S EARLY
EDUCATION page 39

ART TRAINING STARTS IN EARNEST page 49

LIFE AT THE ROYAL ACADEMY page 51

EARLY SUCCESS AND STARTING OUT ON HIS OWN page 57

HELPING THE POOR page 65

A GRADUAL CHANGE OF DIRECTION page 69

THE YOUNG SITTERS FOR ERNEST'S SCOUT PAINTINGS page 77

DUTY CALLS page 85

FAMILY LIFE AFTER ERNEST'S DEATH page 101

AN OVERVIEW AND ASSESSMENT OF THE ARTIST'S page 105
WORK AND CAREER BY ART HISTORIAN PAUL LEWIS

SOUTH LONDON PLAQUES AND AN AFTERTHOUGHT pages 108 - 109

ADDITIONAL NOTES AND IMAGES (CONTENTS PAGE) page 110

**Please note: family tree information can be seen on pages 7 and 8;
old maps can be seen on page 14, modern maps on pages 6 and 33.**

INTRODUCTION

Walk down north Brixton's Foxley Road today and the casual observer can't help but notice a blue plaque on the house (formerly known as Foxley Cottages) where early Victorian artist David Cox once lived. It is quite right that 34 Foxley Road should have its blue plaque (though Cox is not that well-known outside the art world, and it is Birmingham - where he was born - that claims him as their own, rather than north Brixton).

Just a few doors along, at number 42, there lived for around thirty years members of the Carlos family, one of whom became a talented artist. Perhaps not terribly well-known **in** the art world, ironically Ernest Stafford Carlos was and still is a well-known artist to millions of members of the Scout movement in the UK and around the world. To date no plaque exists for this talented portrait painter, perhaps partly due to his being typecast as 'the Scout painter', and also because his promising career was cut short through falling, like so many others, in the mud and mayhem of Flanders. He enlisted, as did most of his compatriots, paradoxically, because he thought that indeed it would be a 'great war' - in size, morals, service and adventure - not knowing what later generations, with the benefit of hindsight, would learn: that it was anything but a great war.

Ernest Stafford Carlos's most famous Scout painting, *The Pathfinder* (1913), is no doubt in the subliminal consciences of millions of ardent and casual followers of Granada Television's soap *Coronation Street*. In the UK's longest running soap series, a framed print of *The Pathfinder* has been seen since the series' earliest days, but latterly - for about half a century or so - it has rested unobtrusively on a wall in the home of fictional Ken Barlow.

To date there has never been a published biography of Ernest Stafford Carlos (whom I shall now refer to simply as Ernest). Very brief snippets of information and biographical sketches have appeared from time to time (usually recycled material) but I, surely like many others, have often been intrigued by the name behind the creator of such evocative and timely paintings. Rarely have images of the artist himself been published. Who was he, where did his talent spring from, where did he train? Such questions, along with those trying to gain further insight into the human life story of such a talented and hard-working individual, remained largely unanswered. A most pleasant surprise it was, then, when I was approached by the family to write a biography of one of their cherished forebears. When I learnt that Ernest, like the author, was a South Londoner, the commission became even more fascinating and pressing.

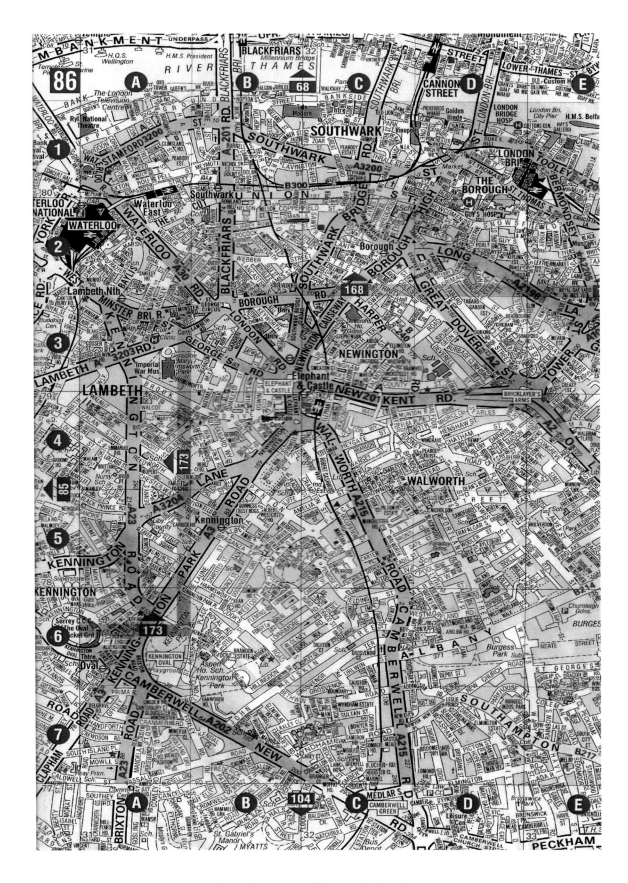

Modern-day map of Carlos's South London

FAMILY TREE AND QUARTERINGS

Artist - Ernest Stafford Carlos
(4 June 1883 - 14 June 1917) son of

John Gregory Carlos and Anne Chessell Carlos (née Buckler)
27 July 1849 - 1850 - 3 Feb 1934 (Daughter of George
19 Jan 1919 Buckler, architect)

John Gregory Carlos
son of

Edward John Carlos and Mary Ann Carlos (née Glascott of Whitechapel)
(solicitor) 12 Feb 1798 - 11 Feb 1813 -
 20 Jan 1851) 25 Jan 1890

Edward John Carlos
son of

William Carlos and Grace Carlos (née Smith)
Gentleman of independent means. Buried at Northfleet, Kent, 21 Aug 1806
Grace Carlos, daughter of Edward Smith of Newington. (Died 19 May 1835, New
Kent Road)

**

Ernest's Mother

Anne Chessell Buckler
daughter of

George Buckler and Emma Sidney Thomas,
(architect) 1811- daughter of Walter Thomas of
Sep 1886 Suffolk, 1818 -1903

George Buckler, son of Charles Alban Buckler (of Bermondsey) and grandson of
John Buckler FSA (of Isle of Wight then Bermondsey)

**

Ernest's siblings: John, George, Grace Mary, Arthur, and twins Edward and Robert

John Gregory's siblings: Mary Ann Edith, Eliza Mary and
Revd. Ernest Stafford Carlos

John Gregory Carlos (merchant's clerk), born: Camberwell 1849, died Jan 1919. Married Anne Chessell at St. Mary's Newington on 5 June 1877.

Anne Chessell (wife of John Gregory, daughter of George and Emma Buckler) born Camberwell Jan 1850, died in Bromley in Feb 1934.
(Both John Gregory and Anne Chessell interred at Nunhead Cemetery.)

George Buckler (architect/antiquary), born: Bermondsey, London 1811, died in Camberwell September 1886. Married Emma Sidney in Bury St. Edmunds, Suffolk 1845. Their first marital home was Cowley Road, Lambeth.

Emma Sidney Buckler (wife of George Buckler, daughter of Walter Thomas), born Suffolk 1818, died in Camberwell September 1903.
(Both George and Emma interred at Nunhead Cemetery.)

**Family motto - Subitus Fidelis Regis Et Regni Salus
('A faithful subject of the King and the safety of the Kingdom')**

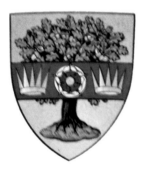

The arms of Carlos.

The arms of Buckler.

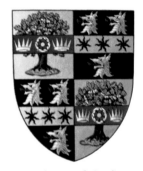

The quarterings of Carlos.

ERNEST'S ANCESTORS

Where to begin this biography? Ernest's family tree is easier to trace than a good many families, for the Carlos family have always been proud of their lineage to one Colonel Carlos who assisted King Charles II in the mid 1600s (the Colonel is mentioned by diarist Samuel Pepys). This starts the story off in Staffordshire (partly hence Ernest's middle name), which I shall come to in a moment, but it is fair to say that Ernest, his parents and grandparents were all South Londoners, residing in and around the neighbouring areas (metropolitan boroughs of London after 1900) of Bermondsey, Lambeth and Southwark. Added here too, must be made mention of the Buckler family, once well-known in the worlds of architecture and antiquary (and they can be traced back to one Sir W Buckler, Knt., 1544). Ernest's mother was the daughter of Camberwell architect and antiquary George Buckler; but the Carlos and Buckler families had links and friendships long before Ernest's mother's marriage in 1877.

To return to those earlier roots, which is where the name Carlos and the family coat of arms originate, we have to thank King Charles II. Prior to this, the family name was one of several variations on Carlos, including: Careless, Carloss or Carlis. It was during the seventeenth century that one William Careless, born at Broomhall Farm, Brewood, Stafford, rose to prominence. William - a name that crops up quite frequently in later generations - kept the Catholic faith when he married Dorothy Fox, *c*. 1633. William would go on to live a dangerous and adventurous life serving as a soldier during the Civil War. During his career he gained promotion, received injuries, was imprisoned, fought for the King in Ireland, emigrated to Spain, secretly returned to England but was forced into exile… (to me, at least, Ernest and some of his siblings always seemed to have more than a hint of Spanish in their complexions!).

It would be an oak tree, later to be a symbol on the Carlos coat of arms, where William Careless made his name. In the Battle of Worcester in September 1651, William, who by now had his son (also William) fighting alongside him, became separated. He sought refuge in his own neighbourhood, latterly managing to conceal not only himself but the King in Boscobel Wood. The legendary account has William senior and the fugitive King Charles hiding in the boughs of an oak tree, all in an attempt to slip their pursuing Commonwealth forces (the King had a sum of £1000 reward on his head). The *Oxford Dictionary of National Biography* tells us:

'As the exhausted monarch slumbered in Careless's lap there was a tense moment when William became so numb that he had to awaken his royal charge to prevent them falling out of the tree and into the hands of the Cromwellian soldiers who were riding along the horse-tracks below.'

King Charles never forgot his soldier's help, indeed William would serve the King on later occasions, but on 21st May 1658 the King gave special recognition to his loyal subject by changing his name to Carlos (Spanish for Charles) and granting him a coat of arms. Other privileges and monetary benefits to the family would follow over the ensuing years.

This story has always been proudly handed down the generations. The Carlos family history, along with British heritage and culture, as we shall see, would be something of a passion for Ernest's paternal grandfather, who also had an artistic flair.

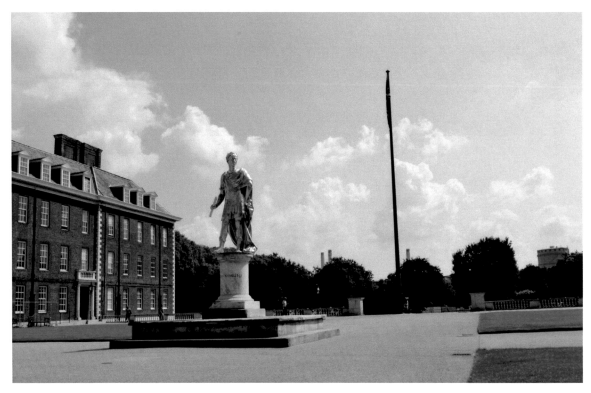

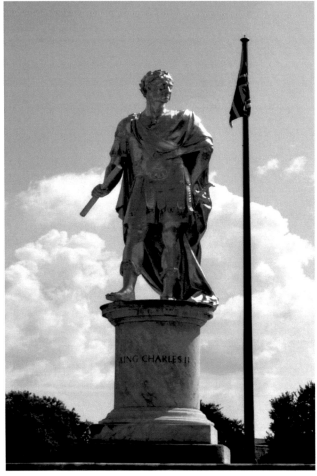

Above and left: With the chimneys of the former Battersea Power Station in the far background, the statue of Charles II stands majestically in the grounds of the Royal Hospital Chelsea (home of the 'Chelsea Pensioners'). Crafted by Dutch-born English sculptor and woodcarver Grinling Gibbons, Gibbons's work can also be seen in St. Paul's Cathedral and in Whitehall - home for his statue of James II.

One scribe described Carlos's deed: *Where Noble Carlos lent his Man-like knee, The last support of Fainting Majestie*. A few hundred years after the Carlos family's support of the King, at the time of writing, a tablet is due to be unveiled at the Royal Hospital in honour of Colonel Carlos. A preview photo is shown on page 11.

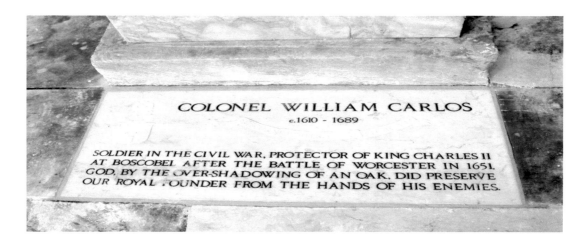

Above: A new addition; the Carlos tablet positioned at the base of Gibbons's statue of King Charles II. It was Charles who founded the Royal Chelsea Hospital in 1682 as a retreat (giving hospitality) for veterans.

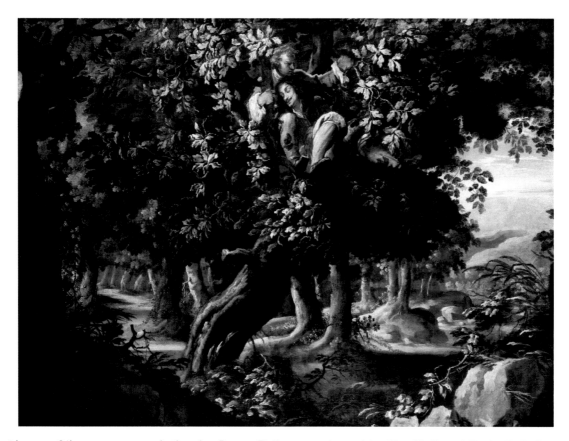

Above: Oil on canvas painting by Isaac Fuller, purchased by the National Portrait Gallery in 1979. Fuller's depiction, c. 1660s, shows Colonel Carlos watching over the sleeping prince while Roundhead soldiers search the wood below them. (As one would expect, the Boscobel Oak is in a frailer condition now, but it is still in existence.)

Overleaf can be seen the one-time popular *Penny Magazine*; one can see why the Carlos family would have had a special interest in this particular edition.

11

THE PENNY MAGAZINE
OF THE
Society for the Diffusion of Useful Knowledge.

522.]

PUBLISHED EVERY SATURDAY.

[MAY 23, 1840.

CHARLES II. AT BOSCOBEL HOUSE.

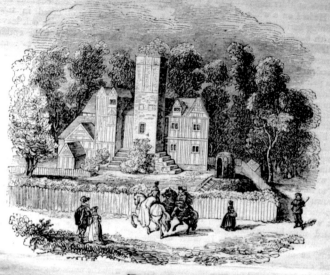

[Boscobel House.]

BOSCOBEL House, situated in the parish of Donnington in Shropshire, is identified with an event in English history which has become better known and has struck deeper into the popular mind than almost any other, if we except perhaps the Gunpowder Plot. By supposing for a moment the most stirring political question of the present day invested with a tenfold interest, we shall scarcely form an adequate idea of the powerful feelings which entered into the contests that divided the country into two hostile parties in the reign of Charles I. The excited state of England between thirty and forty years ago, when an invasion was anticipated, may be compared to the times of Charles I., though wanting the interest and variety of incidents by which they were characterised. At one period Boscobel was the resort of Royalist pilgrims, and the loyalty of many a gallant cavalier has been warmed by the historical recollections associated with the place. These events we shall briefly detail.

After the execution of Charles I. in January, 1649, his eldest son, then about twenty years of age, who was then at the Hague, took the title of Charles II., and in June, 1650, he landed in Scotland, for the purpose of fighting his way to the throne. He was crowned at Scone on the 1st of January, 1651, and, marching into England with an army which he had collected, was proclaimed king at Carlisle. The young king received little encouragement on his route from the gentry of his own party, whom Cromwell's vigorous system had sufficiently overawed; and the spirit of the Royalist army was not animated with that ardent loyalty and devotion which braves every discouragement and grows warmer in adversity: its discipline was also in a neglected state. Charles was therefore in reality but ill prepared to meet his redoubtable opponent, and at Worcester, where the Royalist army had taken up their quarters, Cromwell,

VOL. IX.

whose coming they had foreseen, but never provided against, rushed into the city as to a prey. He commanded his troops to fall on in all places at once, seeming to think it needless, against so ill-ordered an enemy, to trouble himself by delay or circumspection. On the king's side all was confusion—there were few to command, none to obey; and so sudden and complete was the route, that Charles was compelled to join in the flight, lest he should be borne down by his own friends.

The following account of what afterwards befel Charles is principally taken from the story which Lord Clarendon says that he heard from the king's own lips:—The king remained until night with General Lesley and about 4000 horse which had kept together in their retreat; but foreseeing the difficulty that there would be in marching this ill-disciplined army back into Scotland, he left it at night with two of his servants, whom he dismissed at day-break, after he had made them cut off his hair. Charles then concealed himself in a wood on the borders of Staffordshire, called Boscobel, where he lay down and slept soundly. When he roused himself, there came to him a gentleman of the name of Careless, who had also fled from the king's army, and had concealed himself in an oak near the spot where Charles had been sleeping. By this gentleman's advice and help, the king climbed into the oak, and then helped his companion to mount after him. They remained in that tree the whole day, during which they saw many persons who were searching for the king, and talked, in his hearing, of how they would use him if they could take him.

During the whole of this day the king was without food, of which he had scarcely eaten any the day of Cromwell's attack, and it was two nights since he had taken any rest, excepting his short sleep in the wood. At nightfall, therefore, he and Captain Careless came down

2 C

Carlos seal from the family archives.

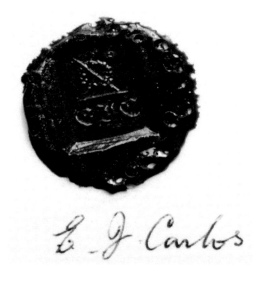

Below: Fulham's All Saints Church, just across the bridge from Putney, has this Carlos memorial floor tablet close to the altar.

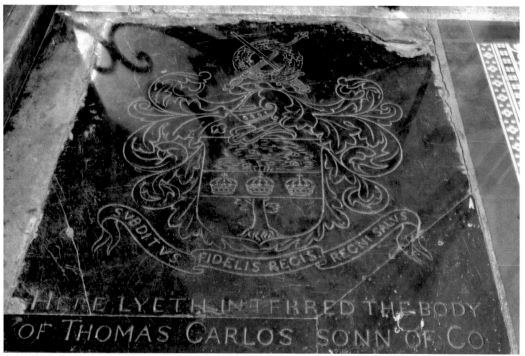

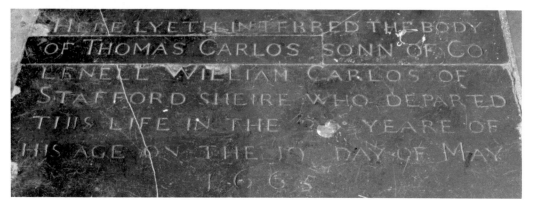

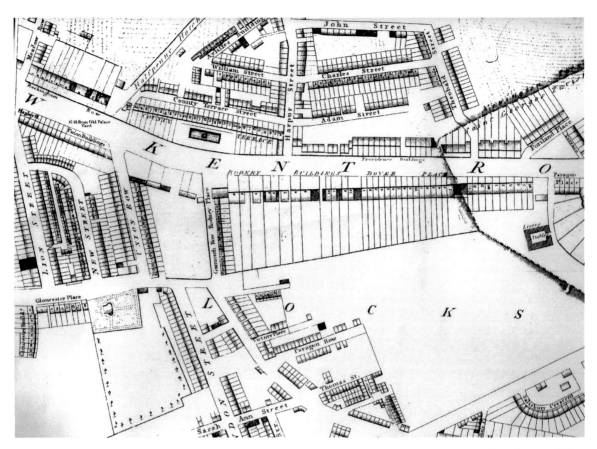

Maps of *c.* 1819. Top: Rockingham Row, the one time home and architects' offices of the Bucklers, can be seen in the top left quarter (the New Kent Road adjoined Newington Road); Ernest John's one time home, Gloucester Buildings, can be seen in the lower left quarter. St. Mary's Church can be seen below (later removed, it is now an open space).

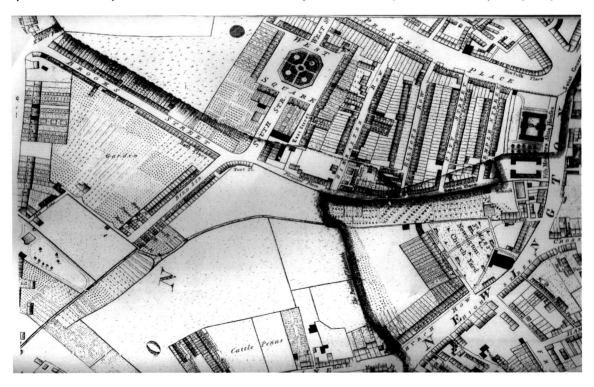

ERNEST'S GRANDPARENTS

Ernest's grandfather was Edward John Carlos, born in Newington, Surrey (near what is now the Elephant and Castle area in Southwark, bordering Lambeth). Born in 1798, and only fourteen years senior to Charles Dickens, the Newington of Edward John's infancy was then but a village on the periphery of London proper. Dickens, in his youth and later, would come to know parts of Edward John's stamping ground very well. Dickens's father, for example, was locked up in Southwark's Marshalsea Prison for debt. An even closer contemporary, on the other hand, is scientist Michael Faraday, born in Newington in 1791.

Edward John Carlos was the only child of William Carlos - a gentleman of independent means, and Grace (née Smith). They lived at Union Row, which was a stone's throw from today's Elephant and Castle and Walworth Road (a general view can be seen on the maps on page 14). Close by was the family church of St. Mary's, Newington. Although Edward John's parents had married at St. George's in the East (in the Borough, heading towards London Bridge), they now lived close to St. Mary's. It would be where the future parents of Ernest were married (albeit in the rebuilt St. Mary's); it also contained the graves of various other members of both the Carlos and Buckler families.

After attending Mr. Colecraft's school in Newington Butts, Edward John entered the legal profession through being articled to Mr. Reynal in Lord Mayor's Court, City of London. Edward John's father appears to have died relatively young (in 1806, though the average life expectancy at that time was only around forty), and Edward John seems to have lived with his mother at Union Row (and/or at nearby Gloucester Buildings) until her death in 1835.

In July 1839 Edward John married Mary Ann Glascott. The Glascott family resided in the vicinity of east London's Whitechapel, where they owned a brass foundry and metal business. For Edward John, the marriage occurred relatively late in life (he was aged 41), though perhaps he had been kept busy looking after his mother and trying to qualify as a solicitor. He first appears in the New Law List as a solicitor in 1827-28. It was said that he ran Reynal's office for the next twenty or so years (Reynal himself at one time resided in South London's Denmark Hill).

Although Edward John and his wife Mary Ann almost shared the same birthday (February 12th and 11th respectively), the age gap between them - he was fifteen years her senior - was quite a wide one. They appear to have initially had a relatively comfortable living nonetheless. At least two domestic servants were employed to look after the burgeoning family, which would eventually total two girls - Edith and Mary - and two boys - Ernest Stafford (uncle of the eponymous future artist) and John Gregory, who would become the father of Ernest.

Strangely, although Edward John was destined to live quite a short life, and though we know comparatively little about him, we do have slightly more on Edward John than we do on Ernest's father and some of his other grandparents.

15

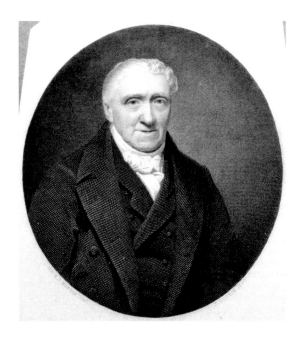

Top left: Newton's engraving of Ernest's great-great-grandfather, John Buckler FSA, who died in 1851 (buried in St. Mary's, Newington). Top right: Ernest's great-grandfather John Chessell Buckler (born in Bermondsey). His son was George Buckler - Ernest's grandfather of 107 Camberwell New Road.

Bottom left: Thought to be George Buckler, Ernest's maternal grandfather. Bottom right: I wonder if it was done by Edward John Carlos himself. It is of his wife Mary Ann (née Glascott), Ernest's paternal grandmother. She died in 1890 at the Exeter Grammar School House, where her eldest son, the Revd. Ernest Stafford Carlos, had recently retired as headmaster.

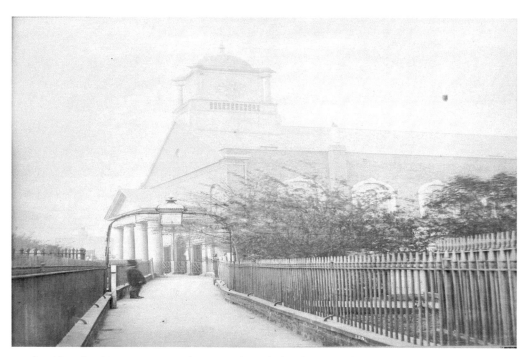

Above: St. Mary's, Newington, where a church had stood for over 800 years. The photo is *c.* 1866, while the watercolour is by Ernest's great-great-grandfather, John Buckler FSA (painted *c.* 1830). With the unfortunate increase in body snatching - a lucrative trade when sold off for anatomy purposes - one or two Bucklers were later removed and buried in more secure places. For others of the Buckler and Carlos families, the relatively new (and marketed as being hygienic) Nunhead Cemetery would prove an affordable and convenient alternative to overcrowded and unprotected graveyards.

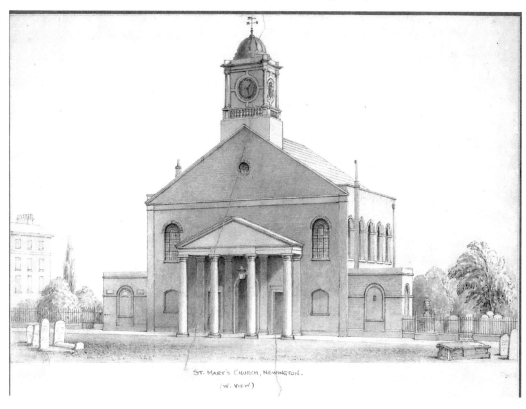

ST. MARY'S CHURCH, NEWINGTON.
(W. VIEW)

Above: the former graveyard and site of St. Mary's, looking away from the Elephant and Castle shopping centre. Scientist Michael Faraday was baptised at St. Mary's. A view towards the shopping centre can be seen below (the landscaped area remains consecrated ground).

THE ROOTS OF ERNEST'S ARTISTIC TALENT

Looking at various members of Ernest's forebears, it is easy to understand why at least one of Ernest's generation would show artistic talent. The National Portrait Gallery has a portrait of Sir Charles Napier (*c.* 1850s) by one William Carlos. He lived in Camden Square, London, but whether he was a close family member or not has yet to be established. On the maternal side, however, there were numerous Bucklers who were both architects and artists, some well-known in their day. The topographical artist John Buckler FSA, for example (Ernest's great-great-grandfather), produced a prodigious amount of work, his drawings of churches and other important buildings are now held at the Bodleian Library, the British Library and elsewhere; indeed, the British Library has around one hundred Buckler items in its collection. For many years John Buckler FSA exhibited his paintings at the Royal Academy. He had eleven children, and it was his son John Chessell Buckler who was runner-up in a competition to redesign parts of the Houses of Parliament after it was destroyed by fire in 1834.

It was partly through the Bucklers' family firm of architects at Union Place and 15 Rockingham Row, Newington that near neighbour Edward John came to know the Bucklers (and their numerous artistically talented relations) well. For whilst Edward John commuted into the City every day and worked tirelessly at his desk, much of his leisure time (perhaps all) centred round preserving the past. It perhaps appears strange to twenty-first century eyes to read of people living in the first quarter of the nineteenth century who wanted to preserve the past and didn't seem to care much for progress and development. For Edward John and some of the Buckler clan were antiquaries - something of an extinct term today (though the Royal Society of Antiquaries still exists after three hundred years, and has its home at Burlington House - along with several other learned societies - which stands close to the Royal Academy). Before the days of widespread publishing of either local or national newspapers, Edward John contributed letters and articles to the *Gentleman's Magazine*, as did at least one of the Bucklers from time to time. The contributions ranged from describing medieval architecture, reviews of restoration projects, critiques of new churches and books, to publicizing preservation campaigns. It was recorded in that magazine (in an obituary) that Edward John first gained an interest in antiquity when a very young man:

In a diary which Mr. Carlos kept from an early age, but portions of which were destroyed in the great fire of the Royal Exchange, is this note, in August, 1817. "About this time and the beginning of the year my predilection for pointed architecture and the study of antiquity began."

It would seem that Edward John was a keen rambler. Perhaps he made use of the exciting new and expanding railway system, when the opportunity arose, to get himself out to the surrounding countryside of Kent and Surrey. Before the days of easy, lightweight and affordable photography, his historical notes, brass rubbings and pencil sketches (occasional watercolours too) must have served as valuable sources of information (the rubbings are now held in the Victoria and Albert Museum). His artistic impressions show practical merit but suggest he had not had the luxury of any serious art training. His enthusiasm,

nonetheless, made him a vigorous campaigner. Southwark's St. Mary's Church (also known as St. Mary Overie - meaning 'over the river'), almost nudging London Bridge, is a case in point. He was the active secretary of a committee formed to preserve it (or notably, the Lady Chapel). St. Mary's, in 1905, became the well-known Southwark Cathedral.

Even the bridge that took one away from the cathedral and across the Thames into the City, was of great interest to Edward John. He wanted to preserve 'Old London Bridge' and published an *Account of the Bridge, with Observations on its Architecture, during its Demolition*. Strangely, some of the stone balustrades from the original London Bridge of 1209 (it has been claimed) were brought to Gilwell Park when the bridge was rebuilt after the Great Fire of London. Gilwell is the Scout movement's national training centre at Chingford, and the said balustrades line the Buffalo Lawn, which is next to the White House (formerly Gillwell House and once owned by the Gibbs family - of dentifrice fame). Other stonework from the bridge that Edward John knew was reused at Stone House, Wandsworth Common and for the pier at Herne Bay.

Edward John also contributed drawings and notes to such works as Allen's *History of London*, campaigned for the preservation of Crosby Hall and, in the last decade of his life, published a series of the descriptions of new churches in the metropolis. Additionally, he wrote annual critiques of the paintings exhibited at the Royal Academy.

Lastly, Edward John was a member of the Cambridge Camden Society. Founded in 1839 and at one time having over 700 members (many with political or religious influence), this traditionalist organization was very influential in the world of architectural design for parish churches. The main objective for most of its members was to see a revival of the architecture of the Middle Ages.

London Bridge *c.* 1750.

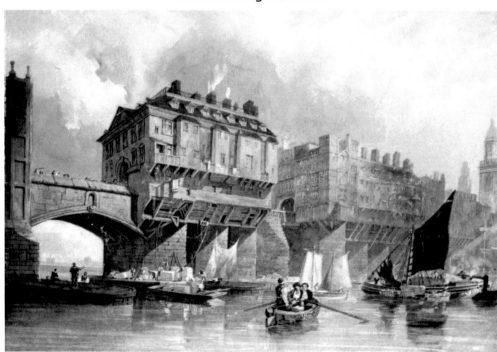

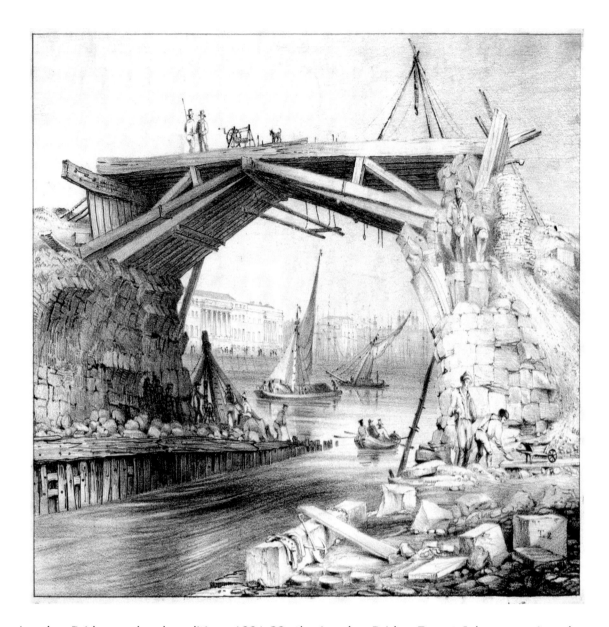

London Bridge under demolition, 1831-32, the London Bridge Ernest John campaigned to save. At one time people had actually lived on the bridge. Its upstream replacement cost £2,556,170.

One early custom, stopped soon after Charles II - who resplendent with 300 soldiers and 300 gentlemen in cloth of silver - rode over the bridge to reclaim his throne, was to display the heads of traitors. Cromwell is one example of the numerous unfortunate subjects. The heads were apparently parboiled and dipped in tar to aid preservation.

Overleaf: The 'new' London Bridge *c.* 1890 with the Fishmongers' Hall (City livery company) on the left. This bridge, designed by John Rennie, was no doubt used by Ernest's father, John Gregory Carlos, when commuting into work. Rennie's bridge was dismantled in the late 1960s and most of it sold to the McCullock Oil Company in the USA, who rebuilt it 1968-71. Thus another 'new' London Bridge was built and opened in 1973.

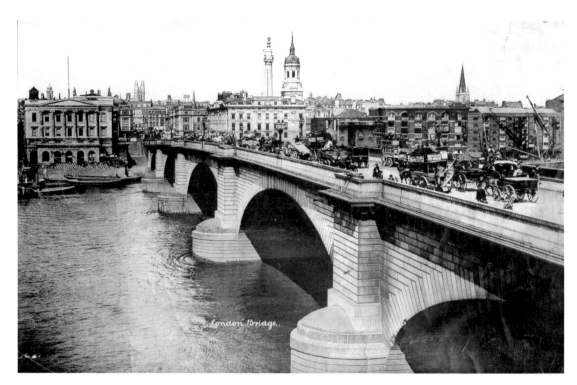

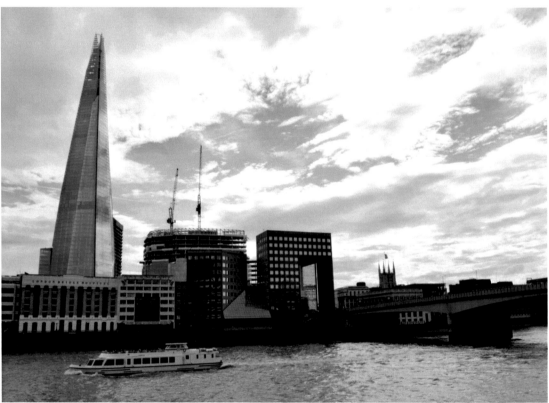

Above: The colour photo shows a more slim-line London Bridge in 2012. Part of Southwark Cathedral (with flag flying) can be seen in the background. In contrast to the photo above, this one is looking from the City towards South London and the Shard, which is Europe's tallest building.

HARD TIMES, AS DICKENS WOULD SAY

With a family that included three young children - a boy and two girls - the solicitor's salary of Edward John, working in Lord Mayor's Court, became somewhat stretched. About 1848 they were apparently also looking after an elderly relative at Union Row, and eventually had to pay the appropriate fee for a respectable send off at Nunhead Cemetery. A much greater burden, however, would strike the family during the summer of 1849. Edward John was struck down with what might possibly be diagnosed today as a stroke but was described at the time as a seizure and 'paralysis of the brain'. The timing couldn't have been worse, for Mary Ann gave birth to a fourth child, second son John Gregory, in the July of that 1849 summer.

It seems that Edward John was incapacitated both physically and mentally. He was unable to return to work, and Mary Ann found herself having to look after him and the children virtually full-time. Funds would be severely stretched and perhaps Edward John's passing early the following year at the age of fifty-two can be viewed as something of a double-edged sword. He was put out of his misery, so to speak (there seemed little prospect of any recovery), but sad as she no doubt was, Mary Ann now knew how the family stood. It was a stark reality. There were no such things as formal rent allowances or sickness benefit, and the youngest child, John Gregory, had not reached his second birthday. What would John Gregory ever remember of his father? He would turn out to be the devoted father of Ernest, but could never have predicted that his own talented son was destined to predecease him.

In a time when everything had to be paid for - burial fees (or else a pauper's burial with numerous other lost souls in an unmarked grave); regular rent or else a swift eviction; school fees; medical costs - Mary Ann would quickly find herself in debt even before her husband's death in January 1851. Her husband was interred in Nunhead Cemetery, a comparatively new and empty cemetery at that time. Being in the legal profession, Edward John had done the right thing and written a will a year after their marriage (the will is now in the National Archives, Kew). The 1840 will was witnessed by colleagues at his place of work, it was written along conventional lines, perhaps with optimistic foresight, essentially leaving any money, land or property to his wife. The problem is they evidently didn't have any property or sizeable funds when Edward John was taken so suddenly (unlike today, probate came through relatively quickly). Money for keeping the family going, along with the average middle-class habit of having two or more servants, must have dried up pretty quickly. With reserve funds depleted and no regular income for the household, Mary Ann faced a fearful future.

Overleaf: The late Edward John's watercolours. The first is of St. Paulinus Church, St. Paul's Cray, Kent (dated April 1832). Below it can be seen another Kent church, along with a present-day comparative photo.

Left: Edward John's watercolour of Leigh Church, Kent. Was it a touch of humour to put his initials on the grave stone (which he dated 1838)?

Below can be seen the same church in 2012 - a little grander and with quite a few more 'residents'.

WHAT WAS TO BE DONE WITH THE ELDEST BOY?

Although Ernest (the artist) was originally named Ernest Charles Carlos - this is what is shown on the birth certificate - the name was quickly altered to that of his uncle. But his uncle (eldest son of Edward John), who would later become the Revd. Ernest Stafford Carlos (and whom I shall for the present refer to as Ernest Stafford), had a much tougher upbringing than his future nephew.

The family appear to have moved quite fast in trying to solve Ernest Stafford's immediate circumstances. The solution would both remove the burden of housing and feeding the eldest child, and greatly improve his future prospects. Perhaps it was a contact in Edward John's solicitor's office who steered the family in the right direction, for even before Ernest Stafford's father had become the late Edward John, their son was admitted as a pupil at Christ's Hospital School in July 1849 (a photo of its London site is depicted below).

Today a well-known mixed boarding school in Horsham, East Sussex, the school (also known as the Bluecoat School due to its distinctive uniform) at that time was in the City of London. Like Reynal's solicitor's office, the school, with its main entrance in Newgate Street, was close to St. Paul's Cathedral. Founded by King Edward VI in 1522 (himself barely fifteen years of age and soon to expire), it had a great heritage for taking in and educating poor children. Past governors of the school include Newton, Pepys and Sir Christopher Wren. On the application form Ernest Stafford's mother had reported that her husband was then of unsound mind and incapable of pursuing his profession. She added that her husband's annual income had been £300 per annum. As it happens, Ernest Stafford was actually too young for the main school so first resided at the junior branch, which was based in Hertford, Hertfordshire (over the years Christ's Hospital would have several junior sites in Hertfordshire, and also catered for girls there too).

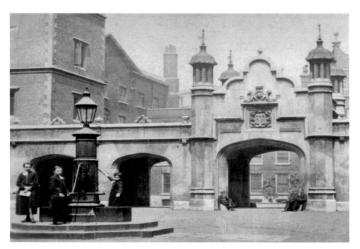

Ernest Stafford 'made good', to use a modern phrase. When he was old enough he returned to the main school in the City. He was appointed Senior Grecian (effectively Head Boy of the Upper School), and went on to gain a place at Trinity College, Cambridge. Although he took holy orders around 1868, the Revd. Ernest Stafford Carlos, as was quite normal at that time, returned to his former school as a teacher. In time he was promoted to Head of the new (for the school) Royal Mathematical School at Christ's Hospital (which was coincidentally founded and granted Royal Charter by that royal favourite of the family, Charles II). From here, in 1881, he progressed to Headmaster of Exeter School, Devon (a little more can be read on Ernest's uncle later on).

But whilst the eldest boy had been taken care of, what was to become of his widowed mother and siblings? It is unclear how well the family first managed after losing the family bread-winner. Possibly the Carlos family found support at one of the Buckler residences. It is known that Mary Ann turned to the Royal Literary Fund (RLF) for help.

At the time when Ernest Stafford joined Christ's Hospital, the school was already quite ancient, approaching, as it was, its tercentenary. Ernest Stafford is mentioned in *The Times* Court Circular of 14th July 1881. It was recorded that the boys and masters of Christ's Hospital Mathematical School came to Windsor Castle to exhibit their drawings and charts to Her Majesty; also that the masters and boys had lunch there.

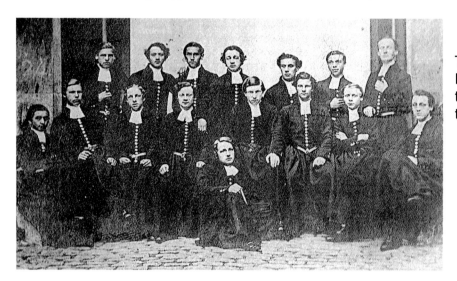

The Grecians, 1861. Ernest Stafford is third from the left in the back row.

Below: 1877, the year his brother John Gregory Carlos would marry. Ernest Stafford here is now a Reverend, but one of the 'newer boys' on the teaching staff. Revd. E S Carlos is third from the right in the front row. One wonders if any of them were happy about having their photo taken! Or were they unfamiliar with new technology? Few seem able to look the camera in the eye. William Haig Brown was a Christ's Hospital pupil in the 1830s (and later became a governor). By the time this photo was taken, he was headmaster of Charterhouse School, where a pupil of his included the future Lord Baden-Powell.

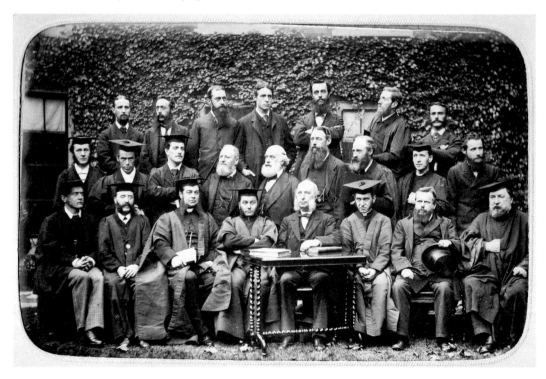

HELP FROM THE ROYAL LITERARY FUND

The RLF was established in London in 1790 to relieve authors of 'approved literary merit … being in want or distress'. It helped a range of authors, including the well-known (D H Lawrence and James Joyce were two later beneficiaries) and those much less well-known. Its supporters included or went on to include Dickens, Kipling and J M Barrie. It found royal patronage relatively quickly (something it still enjoys today) and was rarely short of funds. Dickens entertained members at their dinners and also spoke at some of their AGMs. At times he criticised the committee and its secretary, Octavian Blewitt, most notably for the generally meagre payments it handed out - something, it could be argued, that is borne out in Mary Ann Carlos's case.

First Mary Ann had to have her case recommended to the RLF, and this was done by one 'G. Buckler'. Recorded as being of Shenfield, Essex, presumably he was briefly staying there and was the same George Buckler, author of a book on Essex churches, whose daughter would later marry John Gregory, Ernest's father. There was a slight difficulty in that she was not an author, but she was able to claim as a recently widowed wife of an author, now in distressed circumstances. It also had to be confirmed that Edward John was an author. He had been, first and foremost, a solicitor. He had written articles but usually these were done either anonymously or else under the initials EIC. But he had written sufficient amounts for the *Gentleman's Magazine* and contributed pieces to other works for him to be considered 'an author'. As the transcribed letter below shows, Mary Ann did manage to receive some payments - of £25.00 and £5.00 - which perhaps must have made her feel - welcome or unwelcome I am not sure - something of a member of the 'deserving poor'.

6 York Place
Walworth

June 10 1852

My Lords and Gentlemen

[Penning?] to offer my grateful thanks for the favour you have shown me in admitting my case and for the liberal donation of twenty five pounds which I this morning received from Mr Blewett deeply sensible of your great kindness.

I remain
My Lords and Gentlemen
yours respectfully
Mary Ann Carlos

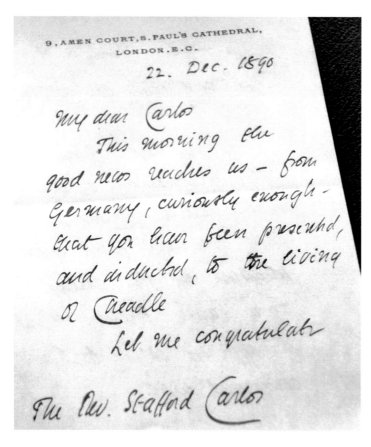

9, AMEN COURT, S. PAUL'S CATHEDRAL, LONDON. E.C.

22. Dec. 1890

my dear Carlos
This morning the
good news reaches us – from
Germany, curiously enough –
that you have been presented,
and inducted, to the living
of Cheadle
Let me congratulate

The Rev. Stafford Carlos

At the end of 1890 the Revd. Carlos became Rector at Cheadle. The letter (page 1 of 2 pages) was from the Revd. W. Sparrow Simpson, Minor Canon, Succentor and Librarian of St. Paul's Cathedral.

Below: Two images of the maturing John Gregory Carlos, youngest child of Edward John and Mary Ann Carlos; also future father of artist Ernest.

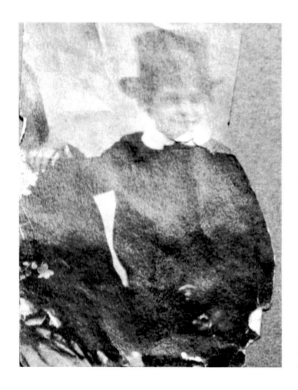

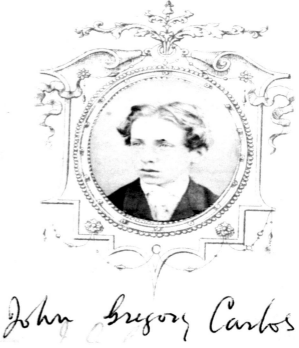

John Gregory Carlos

A NORTH OF THE THAMES INTERLUDE

Times would remain hard for the Carlos family until Ernest Stafford was able to return to London from Cambridge in the early 1860s and combine holy orders with teaching. When that time arrived, the family would have an interlude in their South London residency and live north of the Thames. Ironically, it was close to where Edward John had once practised as an attorney.

Ernest Stafford's first clerical appointment occurred in 1868 when he was appointed curate at the City's St. Lawrence Jewry Church, not far from Christ's Hospital, where he also joined the teaching staff. It has to be remembered that in the mid-Victorian era it was relatively easy to become a man of the cloth, it was often seen as a gateway to other professions. And while there had earlier been scornful critics of the Church, with anti-Church of England protestors viewing it as greedy and far removed from the masses (typified in the following poem and a South London example at the bottom of page 30), many in the Church found it difficult to get on financially.

Remember, remember
That God is the sender
Of every good gift unto man;
But the devil, to spite us,
Sent fellows in mitres
Who rob us of all that they can.

Trying to climb the ladder of curacy, vicar, rector was not easy. A future Archbishop of Canterbury of the Victorian era, Edward Benson, interestingly, had more success than most despite initially showing little promise when he was first examined for holy orders. Benson's biographer, Rodney Bolt, tells us:

... and was ordained in January 1854, despite being unable to answer a single question put to him by the Bishop of Manchester's chaplain when he arrived for his examination as a candidate for holy orders.

With the eldest son now having a reliable income and progressing in his teaching and clerical duties, the Carlos family became more settled. By around 1870 Ernest Stafford was vicar at St. John's, Islington, and the family (including the youngest child, John Gregory) had resided at 50 Colebrook Row, Islington for a number of years. The 1871 census tells us that Ernest Stafford (age 29) and Mary Ann (60) lived at 50 Colebrooke Row, along with two servants.

No doubt Ernest Stafford looked out for his young brother John Gregory. He too managed to get into a good school, the City of London Boys' School, which was then in Milk Street. John Gregory may or may not have known Herbert H Asquith, a pupil at the school, and only three years his senior, but he was destined to become Prime Minister in 1908. Although we know little about John Gregory, we do know that by the early 1870s he was living at 11 King Edward Street, which backed on to Christ's Hospital (King Edward Street also housed numerous other reverend gentlemen and staff from the school). By this time

John Gregory had secured himself a steady and comfortable living as a managing clerk for a merchant's counting house.

Above: Modern-day King Edward Street. It was made in 1843 as a rebuilding of the old shambles called Stinking Lane. It was named after King Edward VI, under whom the Greyfriars monastery beside Stinking Lane was turned into Christ's Hospital for poor children.

This wall tablet can be seen in Newgate Street.

Below: Brixton vicar, the Revd. Matthew Vaughan, was the first incumbent at St. John's Church, Angell Town, where later Carlos boys would attend the church school. When he doubled his burial fees, an effigy of him was burned in the streets (the first Brixton riots?). Here is part of the chorus to a local ballad:

This old Brixton doctor, whom no one can please,
Will have no objection to double his fees.

THE PARENTS AND SIBLINGS OF THE FUTURE ARTIST

South London, in the 1870s, was transforming from areas of open spaces and farmland, to a mix of pockets of gentility and increasing areas of slumland. A small-pox epidemic and flooding of the Thames were additional problems for South Londoners in January 1877. The *South London Press* commented on the January encroachment thus:

The disastrous results of an overflow of the Thames have been so often explified (sic) *that it seems scarcely credible that at the present time inhabitants along miles of the south side of the river are in danger of their lives, and of having their property destroyed by every unusually high tide. Yet that is the case, and scenes have this week occurred which are a disgrace to a wealthy city like London.*

Despite the vicissitudes of that late 1870s winter, a much happier family occasion occurred in the early summer. John Gregory's marriage to the future mother of Ernest, Anne Chessell Buckler, took place at St. Mary's Church, Newington on 5th June 1877. His grandparents had married at St. Mary's, and his father had been baptised there, but the latest generation was actually married at the new St. Mary's, built that year further down Kennington Park Road. With increase in traffic and road alterations (still a great challenge to local planners today!), the former St. Mary's was deemed to abut the road too much and was closed in 1876. Small announcements in both the *South London Press* and *The Times* tell us that it was a family affair: the service was conducted by Revd. J F Buckler MA and assisted by Revd. E S Carlos MA.

In age, less than a year separated John Gregory and Anne Chessell, and the long association between the Carlos and Buckler families would continue also through the proximity of John Gregory's in-laws. The first marital home was 46 Camberwell New Road. Originally a turnpike road, its busy half mile or so length conveyed horse trams which journeyed from Camberwell Green to Kennington Cross, the latter being the end where the Carlos family now lived. Not far away, similarly, at 107 on the northern side of Camberwell New Road lived Emma and (architect) George Buckler, parents to their only daughter Anne Chessell (her only brother had attended a residential school in Clare, Suffolk).

Whereas Emma Buckler hailed from Suffolk, Bermondsey boy George Buckler (the Bucklers once lived in Spa Road) was a mine of local information, having been born and bred in South London. He was said to have been an early riser, a very amiable sort of person, and whilst being very knowledgeable about architecture throughout England, he wrote on local history for St. Mark's Church, Kennington, and also about his passion: English cricket (they lived not much more than a cricket ball's throw away from The Oval, after all). He was quite widely travelled too, for he accompanied the male Buckler clan when they visited France and Spain to paint and record architectural features there.

John Gregory and Anne Chessell's parents had lived closer to the Elephant and Castle area (towards the Thames), and in the first half of the nineteenth century such places as York Place and Union Row were spacious, rural parts of South London, right at the edge of what was considered to be London proper. Towards the end of the nineteenth century, however,

with the population of London doubling, there was an exodus of middle-class people moving slightly further out of London and a migration in of poorer people who needed to be near to their places of work. Charles Booth's map of social deprivation shows that the Camberwell New Road was reliably middle class. There were pockets of poverty close by however, especially as one travelled north towards the Thames.

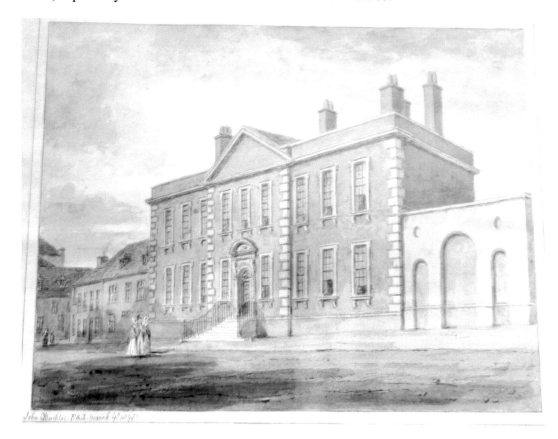

Above: A wedding present painted and presented by John Buckler FSA (Ernest's great-great-grandfather) to Emma Thomas and George Buckler in March 1845 (Ernest's future grandparents on his mother's side). It is a watercolour of the Manor House, a former Bury St. Edmunds residence of Charles Thomas, a relative on Ernest's mother's side. The Manor House was sold in 1876 to the Rt. Hon. Walter Charles Guinness.

Right: Ernest's mother, Anne Chessell Carlos (née Buckler). She is sporting a pair of 'rimless spectacles'.

32

Right: Ernest's father, John Gregory Carlos (portrait painted by Ernest). The glass fronted book case in the background reveals something of Ernest's father's love of books.

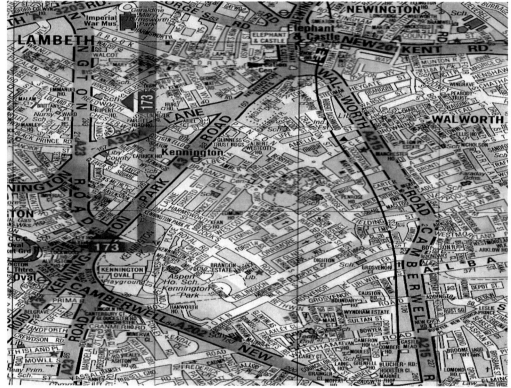

Overleaf: Kennington Cross, close to The Oval cricket ground; also visible is St Mark's Church and, where the bus is about to exit, the beginning of Camberwell New Road. On the left is the edge of Kennington Park (formerly Kennington Common). The primary school attached to St. Mark's is the oldest of its kind in London.

Countless famous names lived in and around Kennington. In addition to numerous artists of long ago, in recent decades the Kennington area has been popular with politicians. Prime Minister James Callaghan had to be persuaded to leave his flat in Kennington Road and live at 10 Downing Street!

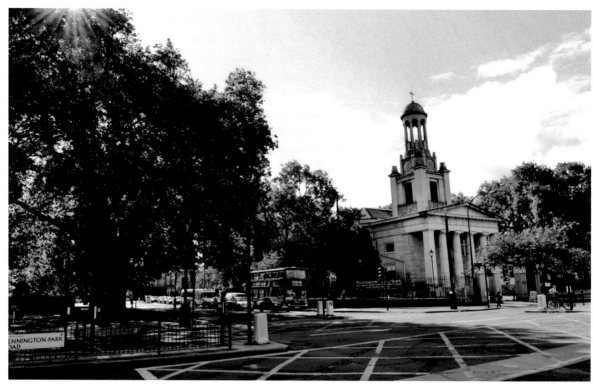

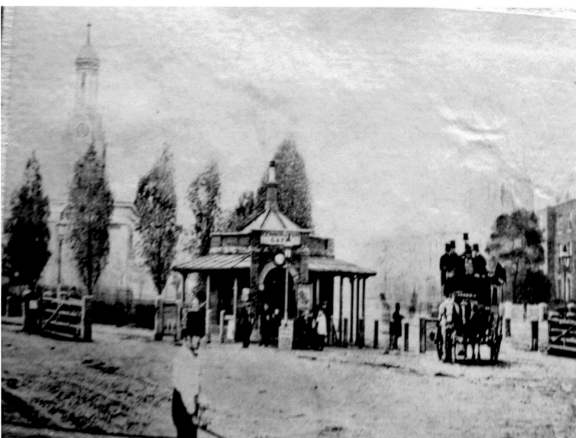

Immediately above: Kennington Gate/Cross *c.* 1850. St. Mark's is on the site of a gallows. In 1848 *c.* 1500 Chartists met on Kennington Common before going on to Westminster to present their petition.

The first born to the latest generation of the Carlos family was one John Buckler Carlos, in January 1880. He, as would be the case with all the Carlos offspring, was born in the new family home (all the offspring with the exception of Arthur - whom I have not been able to connect - were named after grandparents and other family members on both sides of the family). In later life John Buckler would keep the family tradition of holy orders going; it was also he who later assisted Ernest with the founding and running of a South London Scout Troop.

The two consecutive years saw the births of George, then Grace ('Nina', who would turn out to be the family's only daughter). June 1883 saw Ernest, who, for family and friends, was often known as Ernie. A gap of over three years may have looked like family-making had reached completion (John and Anne were in their mid-thirties), but January 1887 saw the arrival of another boy, Charles Glascott (Glascott being the maiden name of Charles's grandmother on his mother's side). Great sorrow would quickly follow, as Charles lived for only sixteen days. He was interred in Nunhead Cemetery.

Almost exactly one year later saw the arrival of Arthur Sidney, who shared his birthday with first born John Buckler. Arthur was quite the academic. He attended Wilson's Grammar School (situated in Peckham, it much later moved to its current site in Wallington). He became a chemical scientist but also took up various Scouting appointments as an adult. When he got married in 1921, to a certain extent history repeated itself. The Revd. John Buckler officiated at Holy Trinity, Tulse Hill; his best man was George Carlos, and the organist was Edward Carlos (see below).

Lastly, the following year (January again) would see 'two for the price of one': the births of twins Robert and Edward. Neither would marry, they were a much loved life-time double-act. Both lived active and interesting lives until their deaths, which both occurred in late 1970. Whilst they were both musical, it was Edward (always known as Ted) who worked professionally as a musician. He was an accomplished church organist and played at various South London churches before becoming, after the Great War, the resident organist at St. Mark's, Bromley. His last post was as organist at the Priory Church, Leominster. Coincidentally, the twins would end their days in Brewood, Staffordshire, territory known well to their distant Carlos relatives.

As it turned out the family was now complete (you can see more details of Ernest's siblings on page 38). The home at 46 Camberwell New Road must have been very full, maybe noisy also. The busy road outside was no doubt even more noisy when dug up around 1903 in preparation for the new electric trams. Possibly John Gregory was aware that it would be prudent to move anyway, as later maps show that houses at his end of the road were demolished (though not the in-laws' at 107) and the ground given over to a large hackney carriage establishment.

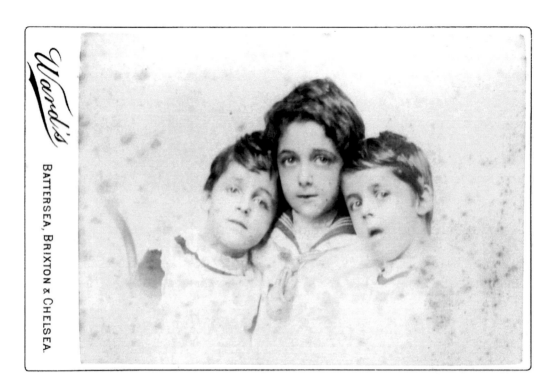

Above: The twins and Ernest in the middle.

Below: The family complete - six boys and one girl ('Nina').

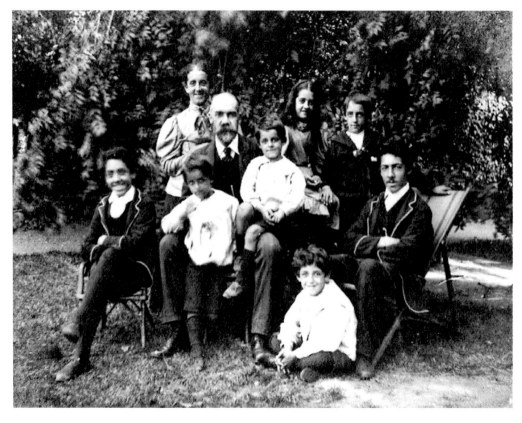

36

Below: A sad reminder of a forgotten Carlos boy, who lasted only sixteen days. He was, however, baptised. This took place at St. Mark's Church, Kennington (the officiating vicar was the Revd. Montgomery, father of the future 1st Viscount Montgomery of Alamein).

Overleaf: Some of the Carlos boys and mother. The boys are well turned out, and the setting suggests their relations (possibly from Suffolk) were quite well-heeled.

John Gregory Carlos and Anne Chessell Carlos's Children

John (Jack) Buckler, born 5th Jan 1880. In 1911 he was an assistant schoolmaster at a secondary school; became the Revd. John Buckler AKC; married Elsie Maude (no children); died 1951. First vicar of Holy Cross Church, Hornchurch, Essex (1926-1945); vicar of King's Pyon with Birley, Herefordshire (1945-1951).

George Edward, born March 1881. In 1911 was a clerk at a drapery store; unmarried; died 1953.

Grace Mary ('Nina'), born May 1882. Unmarried; died 1955.

Ernest Stafford Carlos, born 4th June 1883. Artist; unmarried; killed 1917.

Charles Glascott, born Jan 1887, died Feb 1887. Lived for just 16 days.

Arthur Sidney, born 5th Jan 1888. Went from Wilson's School to Birkbeck College. Became a research/industrial chemist; married, 3 children; died June 1960 in Boscombe.

Twins
Edward (Ted) and Robert (Bob), born Sep 1889. Ted was an organist; Bob worked at the Baltic Exchange; both unmarried; both died in late 1970.

A MOVE TO 42 FOXLEY ROAD, AND
ERNEST'S EARLY EDUCATION

John Gregory was now recorded in census returns as a clerk (sometimes corn merchant's clerk, on another occasion Russian grain clerk, and he may have later worked at the City's Baltic Exchange, which is definitely where one of his sons worked). Presumably finances, despite quite a large family, were healthy, as well before the new century had dawned, the Carlos family moved almost literally just round the corner, into a smart terraced house in Foxley Road. With basement, three floors and ample shared private gardens at the rear, it was a step up for the family. 42 Foxley Road was a quieter, more genteel residence. Whilst leading off the busy Camberwell New Road at one end, at the other was Vassall Road, where the steeple of the relatively new St. John the Divine Church could be seen by much of the milieu of Lambeth (it was actually the tallest steeple in South London). Almost opposite the Carlos residence was the St. John's Institute, which ran a variety of classes and clubs.

We know very little about Ernest's father, he does not appear to have had any artistic or musical leanings. Like his father, he seems to have enjoyed collecting and reading books (Ernest's grandfather's collection had had to go under the Sotheby's hammer soon after his untimely death). It is known that John Gregory was a member of *The Times* book club, but what stands out in family photographs is a relaxed and contented family man. Perhaps because he never had the chance to get to know his own father, John Gregory, with wife Anne, spent all their leisure time with their brood of seven children. When not involved in local church work and charitable commitments, evidence from the family album suggest they enjoyed rambles and seaside visits (alas, the photos are mostly without names, dates or indeed any captions at all - some were originally glass plates). Until her death in 1890, John Gregory's mother lived in the schoolhouse with Ernest Stafford, who was now headmaster at Exeter Grammar School. Ernest's mother's side of the family hailed from Bury St. Edmunds, Suffolk, and a few photographs clearly show family holidays spent there and on the Suffolk coast.

When of age Ernest did not have far to travel to school. He attended St. John's School. Whilst the main school was (and still is) situated on the northern side of Camberwell New Road, Ernest attended the branch in Elliot Road, which was closest to St. John the Divine Church. Ernest's school, known as St. John's Middle Class School, was the only school Ernest attended as a child. Perhaps the logbook entries (see page 42) for the main St. John's School hint at why Ernest's younger brothers weren't sent to the Camberwell St. John's schools (or at least not for very long if they did attend). Three of his brothers, Arthur Sidney and twins Ted and Bob, were sent a longer distance: to St. John's School, Angell Town. It seems a strange choice to send them to this school in Brixton's Canterbury Road/Crescent, and when they moved on to Wilson's Grammar School in Peckham, their 1902 admission entries state - *From St. John's, Angell Town; Much below standard.*

Left: 42 Foxley Road. The previous occupier, like John Gregory's father, had been a solicitor.

42 Foxley Road, along with others in the terrace, is in a conservation area. The Regency houses are three storey and have a basement. Number 42, like most of the other houses, now consists of various rented flats.

Below: Rear view from the communal gardens.

The spire of St. John the Divine can be seen in the distance. Poet Sir John Betjeman described St. John's as 'The most magnificent church in South London.'

St. John the Divine, though not with the ceiling and roof the Carlos family would have known. It was restored after Second World War bombing.

Below: A deceptively green view when shot from this angle.

For Ernest, his time at St. John's Middle Class School, hopefully, was enjoyable (it had seemingly enjoyed an earlier good reputation, with at least one annual sports day being held in the grounds of Lambeth Palace). He would have been used to visits from the vicar of St. John's, the locally well-known Canon Brooke. Canon Brooke was a dynamic and forthright character; with fingers in several pies, he was a leading local figure in education (for example, he founded nearby St. Gabriel's College, a teacher training college for women, now a secondary school). Little could the young Ernest have predicted that he would one day be commissioned to paint a portrait of Canon Brooke. Yet perhaps he did have early ambitions of becoming an artist. The holidays spent with family at Bury St. Edmunds and on the Suffolk coast may well have reminded him of Charles Thomas, an uncle of his mother's. The well-off Mr Thomas was a local art teacher (or 'drawing master') in Bury St. Edmunds. So no matter where Ernest looked, be it in Suffolk, or at the Buckler watercolours in his and other family members' homes, or even the family's connection with the Hollis family - well-known engravers and artists - the stimulation was there. At St. John's and similar schools, too, the syllabus included definite teaching of art, not to mention regular exams in drawing (including drawing to scale). It would seem that Ernest never had the academic potential or interests that took his brothers away from, what appears at the time, to be a rather under-achieving St. John's, to the more high-flying Wilson's School in Peckham. But perhaps there was less surprise than we might at first imagine when Ernest won a scholarship to the Lambeth School of Art.

ST. JOHN THE DIVINE SCHOOL LOG BOOK EXTRACTS

1887, Feb 6 - Severely punished Alf Beard and William Street for playing truant.

1888, June 14 - First lesson in Drill by Sergeant Martin, Instructor of the 1st Middlesex.

June 15 - Prize-Giving by Revd. C. E. Brooke.

Sep 4 - Great improvement in attendance. Several names given by the S. B. Visitor, as those of children illegally employed.

Dec 4 - P J Hill is of little use though he tries hard. [pupil teacher?]

1889, Oct 29 - Several boys punished for street rioting.

1890, June 2 - Mr. Hill left, having completed his apprenticeship. He is giving up the work of a teacher.

1892, June 24 - By consent of the managers, the brothers Ward were sent home, being very dirty and full of vermin.

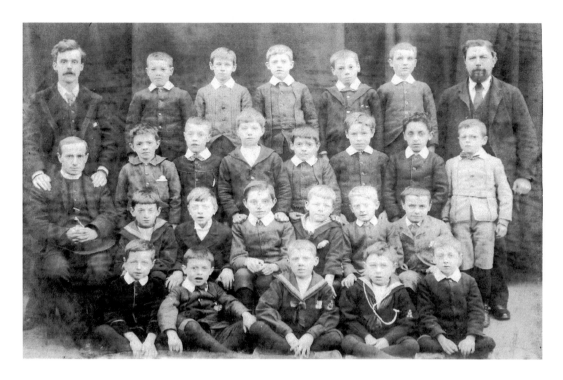

Above: Class photo of St. John's Middle Class School. One of the St. John's clergy, Canon Downe, is first on the left, third row up; Ernest can be seen second from the right, in the same row.

Below: St. John's School, off Camberwell New Road (entrance in Warham Street). Ernest may not have seen much of this school, as his branch of St. John's was in nearby Elliott Road (the building is no longer there).

Overleaf: The former Wilson's School in Wilson Road, Peckham. This is where at least three of the Carlos boys went to school.

Founded in 1615, Wilson's moved to its current Wallington site in the mid-1970s. The Wilson Road site, where the Carlos boys attended, was opened in 1883 - the year of Ernest's birth. The original name can still be seen in the wall today; rather ironically perhaps, it is now the Camberwell School of Art. The school magazine mentioned the Carlos boys from time to time. It tells us, for example, that the twins were in the school rifle club. Later, musician Edward conducted the orchestra for the Old Wilsonians' 1912 entertainment (in 1915 he was awarded a fellowship at the Royal College of Organists). As we shall read later, the year 1912 would be a tragic one for the family of one particular Wilsonian: William Beckham.

The School Building used from 1883 to 1974

The school lay between Wilson Road and Dagmar Road, Peckham
(close to St. Giles's Church).

44

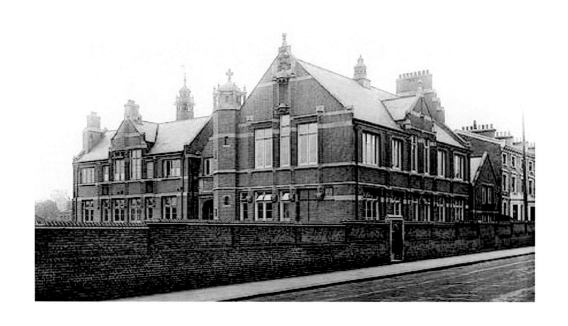

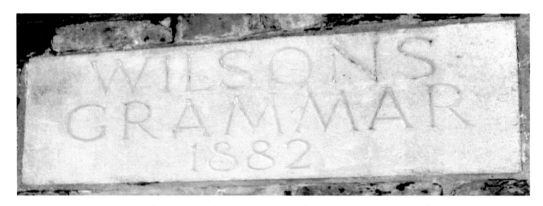

The original name can still be seen in the wall.

Below: Views from Dagmar Road and (bottom) Wilson Road.

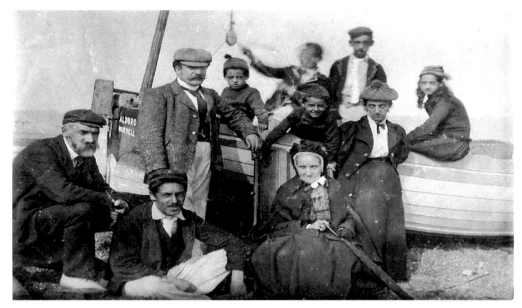

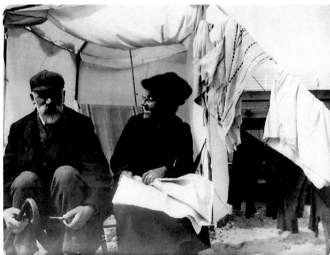

Above and left: Photos from the family album - school holidays spent in Suffolk.

Left: Ernest's parents, in relaxed and jovial mood. This is probably a later photo, when the children were all young adults, but it has to be remembered that when Ernest was 11 his dad was about to turn 45.

Right: A family audience view the emerging artist. Can you detect the three-wheeler for the elderly (possibly grandmother) relative?

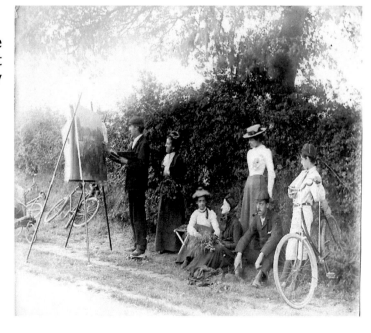

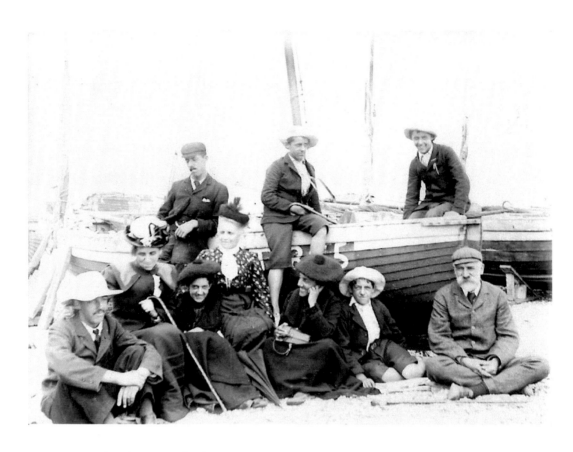

It may be the seaside, but all will keep heads covered (ladies their legs also) and adult males will still wear a tie. Or was it a Sunday?

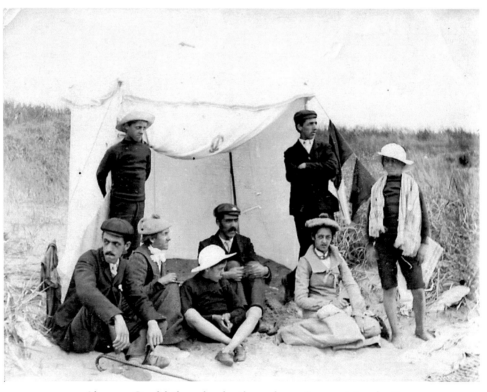

Above: Could they be bathers hanging out to dry?

ART TRAINING STARTS IN EARNEST

Situated in St. Oswald Place, the Lambeth School of Art was within reasonable walking distance of Foxley Road. Although other art schools began to pop up in London and many other large towns or cities towards the end of the nineteenth century, the Lambeth School of Art was a very early starter and is said to be the first of its kind in London. It started life as a night school. In 1854 Canon Gregory set up the night school in St. Mary the Less Church, which was in what is now called Black Prince Road, Lambeth. It would go on to have close links - both artistically and employment wise - with the local Doulton Pottery.

It outgrew its shared church school accommodation and moved to purpose-built premises on part of the old Vauxhall Gardens, situated in what is now called St. Oswald Place but was then known as Miller's Lane. The foundation stone was laid by the Prince of Wales (later King Edward VII) in 1860; this act was said to have been the first formal public task undertaken by the Prince.

It would never be in the same league as other later schools such as today's Slade School of Art (founded in 1871), yet over time it had instructors of good repute - such as the sculptor Charles Sargeant Jagger - and numerous well-known former pupils, among them: George Frampton, Stanhope Forbes, Arthur Rackham and George Tinworth. (Incidentally, it was local benefactor, Kennington's Felix Slade, who bequeathed money which led to the founding of the Slade school.) The latter mentioned, George Tinworth, sometimes pawned his coat to help pay the fees at the Lambeth school; he became a leading ceramic sculptor at Lambeth's large and enterprising Doulton works. Buried in West Norwood Cemetery in 1913, the monument on the family tomb was destroyed by the London Borough of Lambeth, who chose to reuse the grave for new burials in the 1980s.

Well before Ernest was a pupil, after being taken over by the City and Guilds of London Institute in 1879 the school was extended further by the renting of 122 and 125 Kennington Park Road, where new studios were built. Whether or not Ernest had any great interest in the Doulton side of the school is unrecorded, but he appears to have used his time wisely and certainly managed to impress his mentors. At the tender age of seventeen he won the National Medal (South Kensington) in 1900. He soon after exhibited a small painting titled *Soldiers* at the Royal Academy; it boded well, for in July of the following year his potential and success were rewarded further. With a recommendation from Royal Academician Briton Rivière, Ernest won a three-year scholarship at the Royal Academy Schools (RA - then and now based in Piccadilly), which was later extended for a further two years.

Entering the RA must have been an exciting time for Ernest, and his family were no doubt very proud of him. Several Bucklers, of course, had exhibited at the RA, but just prior to Ernest's time there, such promising students - future household names in the art world - as Gascombe and Frampton had trained there. A friend at the Academy and an almost exact contemporary, one with whom he would briefly share a studio, was Frank Beresford (middle name Ernest!). A local newspaper lists Ernest as being one of the guests at Frank Beresford's Crouch End wedding in 1910. Beresford would go on to have a distinguished career as a portrait painter and war artist; later in his career he was commissioned to paint the portraits of Queen Elizabeth and King George VI.

Below: Ernest's first 'big' school, in St. Oswald Place. The other side of the building backs on to Vauxhall City Farm. Today the former art school is divided into private apartments though their spaciousness and high ceilings provide a sense of what the school must have been like. The school had expanded considerably by the time Ernest was there (it catered well for female artists too), so Ernest may well have been attached to the school's newer studios in Kennington Park Road. It is perhaps strange to think that for the first seven years of Ernest's life, the painter Vincent Van Gogh was still alive. When working in London, he lived about ten minutes from where some of the Carlos and Buckler family members lived, in north Brixton's Hackford Road (number 87 now sports a blue plaque).

Whilst the Carlos siblings were all doing quite well, local lads Charlie Chaplin and his brother would have a much harsher experience. Both spent time as paupers in the local Workhouse. Walworth boy - former Lambeth Art School pupil and Doulton sculptor - George Tinworth, also had humble beginnings but did rather well for himself (and is commemorated in Lambeth's Tinworth Street). Ernest, too, must have seen both the splendour and darker side of South London when coming to the art school each day. Orphanages and soup kitchens were never that far away from the genteel squares and the likes of philanthropist Felix Slade (of Walcot Place), whose house was said to be crammed with priceless pieces of art.

The Lambeth School of Art was on the site of the famous Vauxhall Gardens, in earlier times the Gardens had been a favourite haunt of diarist Pepys and members of the royal family, who enjoyed the fireworks, refreshments, walks and other entertainments. It is said that in 1749 12,000 people watched the 100-piece orchestra rehearse at the Gardens for Handel's Music for the Royal Fireworks. It had not been closed for that many years when the site was cleared for the building of the Art School. Local roads still commemorate early managers at the Gardens: Jonathan Street and Tyers Street.

LIFE AT THE ROYAL ACADEMY

Go to the RA today and, physically, much of the building would be recognisable from when Ernest was there (particularly behind the public areas). The life class studios used by today's students, too, would be easily recognisable to Ernest. Hopefully, some advances had been made in teaching methods by the time of Ernest's arrival. Earlier students had had to listen to lectures on anatomy which were accompanied by portions of human body preserved in spirit - said to be unpleasant and almost useless. On the other hand, even during Ernest's time there the late Victorian attitudes would no doubt seem comical to today's students. At Ernest's local church, seating at St. John's had largely confined women to one side of the church, and men to the other. At the RA, similarly, for decades male and female students had had to work in different parts of the school. When female students finally had their request for a nude male model granted in 1893, there were strict guidelines to be followed (and one wonders if 'nude' was not a rather exaggerated term!):

It shall be optional for Visitors in the Painting School to set the male model undraped, except about the loins, to the class of Female Students. The drapery to be worn by the model to consist of ordinary bathing drawers, and a cloth of light material 9 feet long by 3 feet wide, which shall be wound round the loins over the drawers, passed between the legs and tucked in over the waist-band; and finally a thin leather strap shall be fastened round the loins in order to insure that the cloth keep its place.

Women had to be persistent but sometimes, as in the case of the Suffragettes, they were aggressively so. One of several such acts saw, in 1914, a woman smash the glass and slash the canvas of John Singer Sargent's portrait of Henry James (Sargent had been one of Ernest's tutors).

By now a lithe and - for the time - tallish man, the calm and studious Ernest appears to have lapped up everything the RA had to offer - both in learning the technicalities and enjoying being among other artists. Photos depict him as being on the one hand assiduous - taking his work seriously - and on the other being jovial and a good mixer. As at Lambeth, his talent was spotted early and encouraged.

Right: Earlier members of the family were already very familiar with the Royal Academy.

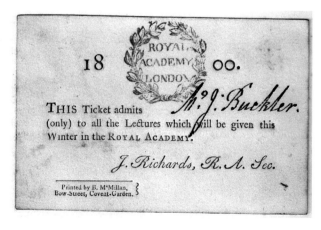

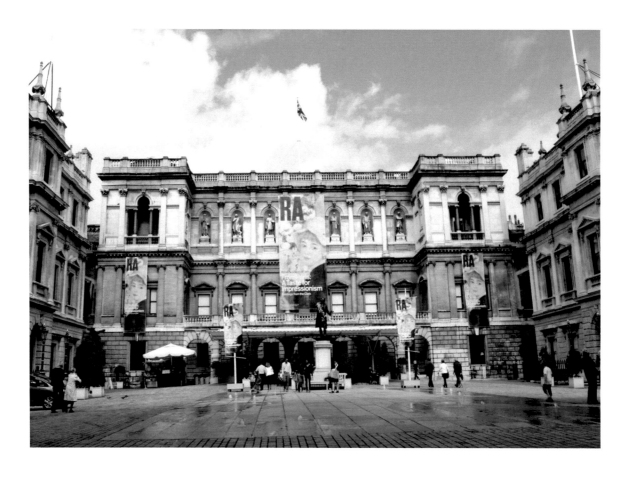

Two views of modern-day Royal Academy showing public frontage; the art schools are below and at the rear of the public galleries.

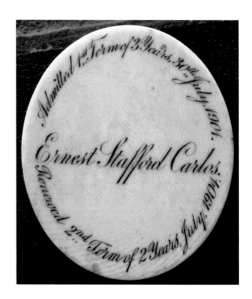

Right above: Ernest's ivory disc given to him as a new student. As can be seen, information was added as his tenure was extended. One or two earlier students had referred to the discs as old 'bones'.

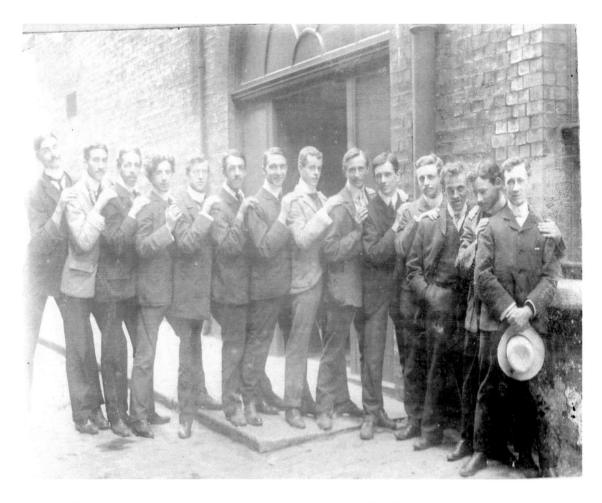

Photos from when Ernest was at the RA (photos from the family archive). In the top photo Ernest can be seen sixth from the left. The photos below are dated 1903.

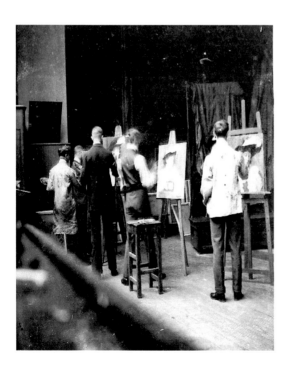
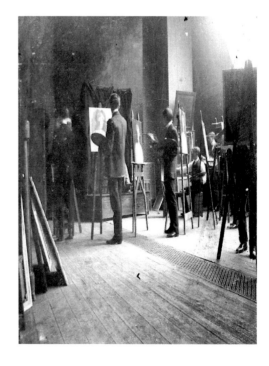

The training Ernest received at the RA was quite thorough and perhaps rather traditional. On the one hand it gave students a good grounding but on the other it could be viewed by some as being somewhat safe and uninspiring. An article in the art journal *The Studio* had this to say in 1903:

The President of the Royal Academy, Sir Edward Poynter ... did not point out the very obvious defects of the academic training ... the general quality of the work remains precisely what it was during the last years of the nineteenth century. The drawings from the life are still obsequious in their regard for shading, and the major part of them are careless and weak-handed in other things of much greater importance ... a life drawing by a student of the Royal Academy has usually the effect of a thing laboriously pieced together; it lacks that feeling for construction which is encouraged in the best schools on the Continent of Europe.

As all good new artists would have tended to do, it is known that Ernest did visit Paris to broaden his horizons, and similarly he went down to the favourite haunt of both burgeoning and more experienced artists from across Britain: Cornwall's Newlyn, with its wonder of sand, sea and exceptional qualities of light.

Lastly, Ernest's friend and fellow student Frank Beresford had first trained at Derby Art School and then at St. John's Wood, London. His biographer John Fineran commented on Beresford and his contemporaries' experiences at the RA schools:

In addition to this absorption with the coldly representational, Frank Beresford and his fellow students would somehow need to navigate their passage through the Royal Academy Schools' lingering and overlapping traditions of allegory and history painting, classical legend and symbolism, all of which swirled through the studios, galleries and publications of the period.

His daughter Averil much later wrote: There is a certain vigour about my father's early work which was dampened by his ten years of conformist study in Art Schools, including five years in the Royal Academy Schools.

For Ernest, as an up and coming artist, it bode well that he was developing into a skilled portrait painter, this would be the bread and butter work that would give him a living and reputation even if it did not always stretch his creative instincts. For Ernest's vigour and unique style to shine through, it would take six or so years post-RA training. Only then do we see his true interest and unique style in paintings that revealed more about a different age group and class in society and explored moral consciences.

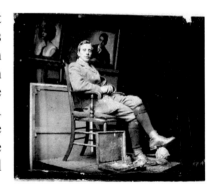

Right above: Frank Beresford as sitter for Ernest.

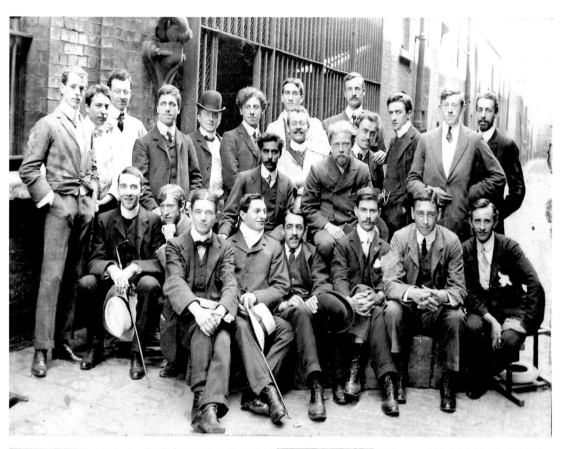

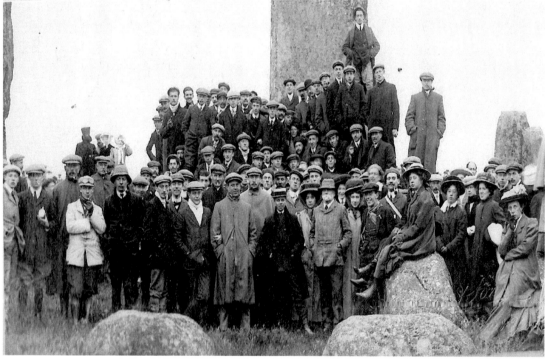

Immediately above: Not your typical works outing - members of the RA schools on a visit to Stonehenge. In group photos today we might wonder: Is there anyone without a mobile phone? For this group photo, we might muse: Is there anyone without a hat?

Below: The Life School studio that Ernest would have known. Little changed, it's still used today (not that the RA hasn't changed in other areas. Tracy Emin became its first female professor in 2011 - Professor of Drawing).

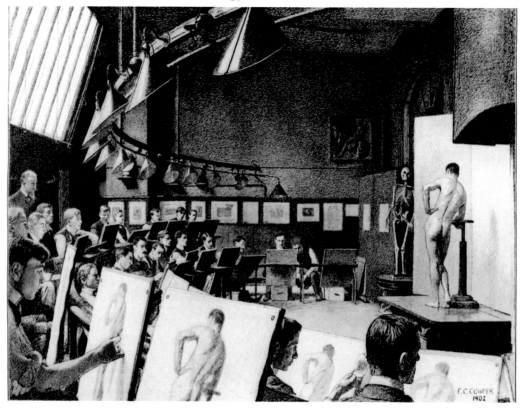

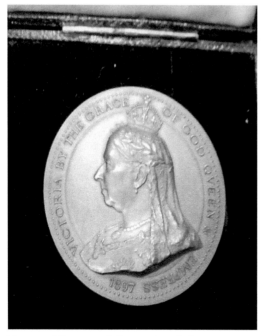
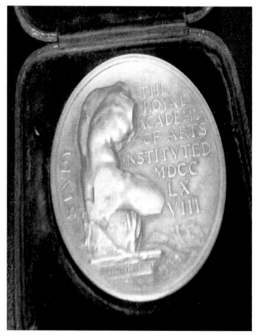

Above: The medal on the left was awarded in 1900, it is a national medal for success awarded by the Board of Education. The second is Ernest's 1904 award for the best of six drawings of a figure from the life.

EARLY SUCCESS AND STARTING OUT ON HIS OWN

Ernest's first exhibition at the RA in 1901 (*Soldiers*) was a promising start, other awards and later exhibitions would soon follow. While he was at the RA Ernest won the Landseer Scholarship for a painting in 1903 (Academician Charles Landseer was not as famous or prolific as his brother Edwin, who first exhibited at the RA when aged just 13, and whose bronze lions can be seen around the base of Nelson's Column, but his endowment fund lives on today for promising RA students). The Landseer Scholarship was followed by a British Institute Scholarship in 1904 and the Royal Academy Silver Medal in the same year (and again in 1906). The latter was topped by a Gold Medal at the Bury St. Edmunds Exhibition in 1908. For such a young artist these were very worthy accolades.

A small pocket book (almost complete) from 1904 to 1914 survives and details Ernest's numerous commissions. They show how flexible he was: in what he was prepared to paint, who he would paint for and where he would travel to execute each job. He was still living at the Foxley Road address, but he had by this time (*c.* 1904) set up his own studio in the family home. Although Ernest may have been less travelled than some of his peers at this time, he was still carving a respected name for himself. His studio may well have been (or else included) the large wooden extension in the garden remembered by a few of his young sitters.

The inventory suggests that Ernest had both a methodical and business-like approach to his work. One can also see the snowball effect: it would appear that word of mouth spread quite quickly. He was always approachable and on call (within a few years he would even be in the telephone directory), and could visit clients or else do paintings in his studio from miniatures and photographs. The clientele soon included the aristocracy and members of the Church. One minute he could be up in Scotland, the next, at Church House, Salisbury. In fact, from 1905 to 1911 he was a regular visitor to Salisbury Cathedral, where he painted portraits and copies of portraits of Bishops and other clergy or their family members (even their dogs on occasion!).

It was at Salisbury where he saw one aspect of 'boy work'. The Scout Movement did not properly start until 1908 (after publication of Baden-Powell's *Scouting for Boys*), but at Bishop Wordsworth School he helped out when the boys were in camp. No doubt, too, he had seen the Church Lads' Brigade in London, for St. John's ran at least one company (the Boy Scouts, although soon to dwarf the Church Lads' Brigade and the Boys' Brigade, was quite a late starter compared to these two organisations which were already well established in parts of South London and in other places across much of Britain).

When the demand for copies began to flow, I'm not sure if he found these an exciting challenge or, after a while, simply rather tedious. But they became quite a lucrative part of Ernest's work. As a more extreme example, when he was asked to paint the late Canon Brooke's portrait in 1911, over time it led to about twelve or so copies being requested by relatives and members of the clergy. Copies became something of his bread and butter work, but from about 1909 we can see the artist's new interests emerging, both as subject and moral concern. His painting *Rejected and Dejected* no doubt reflected what Carlos

could see in parts of South London, as would be the case for *Good work in a London slum*. Indeed, the image for the former was used for an Independent Labour Party leaflet (depicted below); it was also published in the magazine *Bibby's Annual*, a large glossy magazine which carried political and social commentary as well as numerous illustrations of paintings from well-known artists of the day.

Other paintings began to utilise a youth/Scouting theme, seemingly suggesting that boys needed to be shown the right path: they needed to be given direction, choices, shown the benefits of responsibility, duty and industriousness. Ernest's paintings *If I were a boy again* and *The Pathfinder* (*c.* 1911 and 1913 respectively), although they quickly caught the attention of the Scouting world, perhaps became even more popular after his death. And although *The Pathfinder* was and remains the most enduring image from Ernest's Scouting repertoire, it would seem that for many - including Scouting's founder - his first painting *If I were a boy again* (shown on page 73) was more of a favourite.

Whilst it is right to remember Ernest for his significant influence on the Scout movement, we must not forget that even at the time when he was both more involved in the Scout movement and painting Scout subjects, his repertoire was not exclusively Scouting. The family today still has some of his paintings (others were auctioned off in the 1980s), and some of his portraits still exist in quiet rooms, corners and corridors across Britain. Church House, Salisbury, for example, has a Carlos portrait; at Brasenose College, Oxford, can be seen Ernest's portrait of Bishop Wordsworth. Included on pages 106 are a few other examples which show something of his wider skills and preferences. Lastly, an objective overview and critique of the artist's work is provided by art historian Paul Lewis on page 105.

 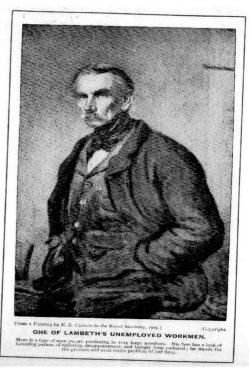

It was said that Ernest used to see the sitter for this painting, an unemployed man, standing outside a Church Army shelter in London and began to chat with him.

EXTRACTS FROM ERNEST'S INVENTORY NOTE BOOK

1904 - Aug. Mr. King, painted at Manor House, Bury St. Edmunds. 30 x 25, £10-10-

1905 - Nov. Copy of portrait of Bishop of Salisbury by Sir George Reid. Painted at Church House. Size just over 50 x 40, £30.00. Expenses paid 3 weeks - 1 month.

1906 - Jan. Copy of Hoppner for Duke of Argyle, painted at Inverary Castle. Jan 18 - Feb 21, £40.00. Expenses £15 - 12. at Roseneath.

Apr. Violet, daughter of Mrs. J. Green, age 5. Size about 50 x 45, £20- -.
Jul. Copy of portrait of Catharine II of Russia for Countess Bobinsky. In Paris, size about 10 x 4.6. Aug 1 - Sep 6, £65- -
Dec. Bishop of Salisbury by Sir George Reid for Brasenose College, Oxford. 24 x 20, £35- -; black and gold Dutch frame.

1907 - Sep. Portrait of Lewis Coward KC, Recorder of Folkestone, Secretary of the Royal Academy. At Rutland Court, Knightsbridge. About 44 x 34, £50- -
[Presented at the Burlington Hotel, Folkestone]

1908 - Jan. Portrait of Betty, daughter of Mr. Le Corni of Jersey. Painted in Jersey, £10--

1908 (no month). Dog "Spot" for Robin Wordsworth by arrangement. [Other dogs followed for other clients, including "Pippin and "Dingo"; it is also recorded that in November he was in Sheffield painting dogs]

1909 (no month). Lord Bacon for Grays Inn, to be presented to Masters of Trinity College, Cambridge. Size about 40 x 30, painted in studio, £30 - -

1910 (no month). HRH Princess Louise for Roseneath. Full length, £40- -. [Later asked to do further copies - needed at Kensington Palace and Inverary Castle]

1911 - Jul. Canon Oldfield. 30 x 25, £10.00, painted at Salisbury.

Nov. Canon Brooke for Mrs. Brooke. 14 x 10, £5.5-

1912 - Sep. Gen. Jeffreys of Doddington Place. £40.00

Dec. Mr. Chapman for 12 lessons. £10.10-

1913 - Jan. Taylor & Co for reproduction of *If I Were A Boy Again* in *Church Monthly*, £2.0.6.

1914 - Jan. Portrait of Canon Fox Lambert. £80.00

1915 - Mar. Portrait of Mrs. Henderson. Sedgwick Park, Horsham. £18.00

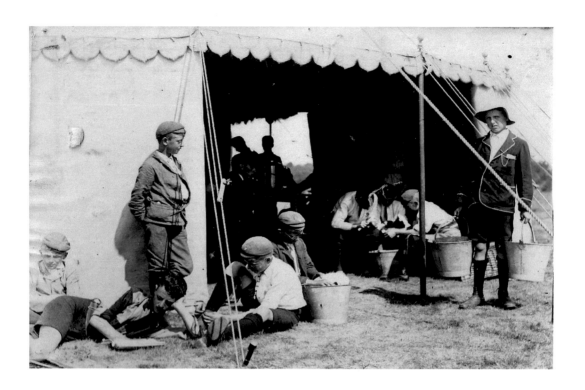

Here and overleaf: Scenes from the Bishop's School camps, where Ernest helped out most years, 1908 - 1911. Some of the boys are relaxing while others are on 'fatigues', doing their turn at spud bashing or collecting water. When camps such as these were enjoyed by less privileged boys - Boy Scouts and others - the term Muscular Christianity was often applied. Scout camps, however, were unique in that boys were given much greater responsibility to manage their own affairs; older boys were made Patrol Leaders and nurtured those under them.

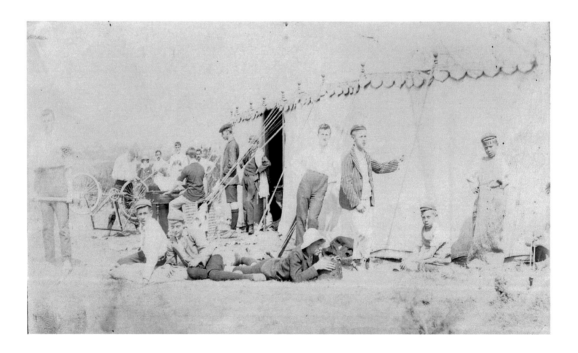

Founded in 1889, and colloquially known as 'Bishop's', the school was relatively new when Ernest knew it. Future novelist (famous for *Lord of the Flies*), William Golding, was a master there before and after the Second World War.

Elliott & Fry, THE BISHOP'S SCHOOL, SALISBURY. London, W.

I wonder if Ernest was ever aware that his relative John Buckler had earlier designed an altar-screen for Salisbury Cathedral. In fact, in 1803 he exhibited two paintings of the Cathedral at the Royal Academy (there were very few cathedrals he hadn't painted).

Above: The Carlos men sport their trademark: well trimmed moustaches.

Below: This and the other studio views suggest a busy time. The panel piano would have been considered quite old even at that time, although it does hint that Ernest may have had some musical ability as well as artistic skills. When he started his Scout Troop they quickly formed a band; hopefully the buglers did not do as a few others were wont to do and make a raucous racket which tended to undo the widespread popularity the Boy Scouts had in many areas.

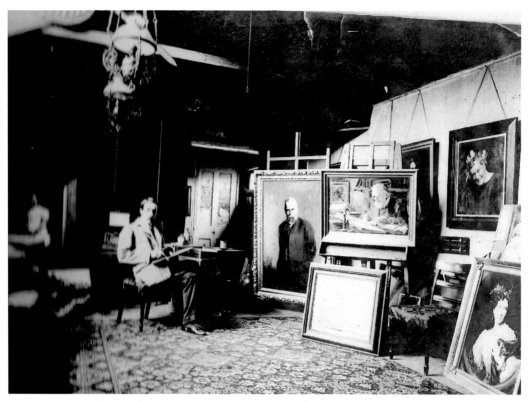

The artist at work: with props and works in progress.

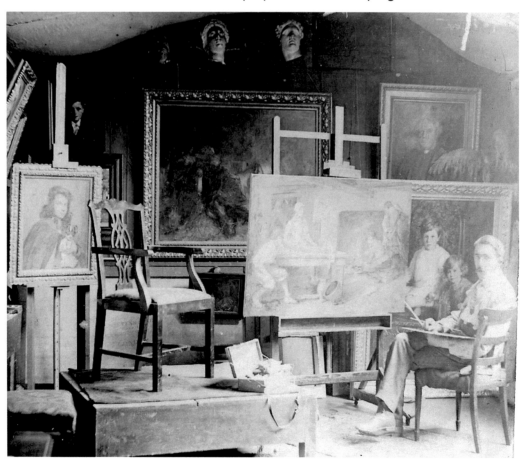

PAINTINGS EXHIBITED AT THE ROYAL ACADEMY

1901 *Soldiers*
1909 *Rejected and Dejected, One of London's Unemployed*
1911 *If I were a boy again*
1912 Sir Richard Oldfield; *Be Prepared* (later renamed *Headquarters*)
1913 *Good service work in a London slum*
1914 The Bishop of Kingston
1915 *Separation Allowance*

A set of Six Drawings of a Figure from the Life won Ernest 1st Prize, £20, and Silver Medal in 1904. He was mentioned in *The Times* on 12th December 1906 for best painting of a Head from the Life.

OTHER PRINCIPAL WORKS INCLUDED THE FOLLOWING PORTRAITS

The Dean of Salisbury
Canon Brooke, St. John the Divine Church
Frederick Rogers
Sir Launcelot Cubbins, Director General RAMC
General Jeffreys
Lewis Coward KC, Recorder of Folkestone
Canon Johnston, formerly principal of Cuddesdon College
Miss Bishop, principal of St. Gabriel's College
Canon Fox Lambert, founder of Bishop's College, Cheshunt

Below: This large painting by Ernest is still kept in the family. It is one of several examples they have that show Ernest's wider skills. The Penderells were a Shropshire family who helped with King Charles's escape. A caption on the frame reads: 'King Charles II with Col. Carlos at the Penderells'.

HELPING THE POOR

The chances are Ernest already had an upbringing that gave him a social conscience. He and his siblings attended church, though whether there were particularly strong links with St. John's is open to conjecture. Ernest, the twins and sister Nina, for example, were all baptised at St. James's Church, Kennington Road (the church is no longer there). His brother Jack was destined to become a vicar, with his first post being as a curate in East Ham. Their mother immersed herself in charitable work, notably with a children's hospital.

The Belgrave Hospital for Sick Children was originally based in Pimlico but was rebuilt in Clapham Road around the turn of the century. From about 1904 Ernest's mother became interested in its work and, by 1910, had founded her charitable organisation known as the Childer Chaine (deriving from 'children's chain'). The Childer Chaine was first a children's organisation where children raised money for the hospital (by collecting farthings, for example). But funds for the upkeep and comfort of the sick children at the hospital were increased further when the Childer Chain was extended to include adult branches too. Ernest's mother was actively involved with it (and various family members were roped in too) almost right up to her death in 1934.

Although it has sometimes been said that Ernest discovered the slums and poverty of London's East End, where that great Scouting stalwart and Commissioner Roland Philipps based himself after coming down from Oxford, I have seen no evidence for this. On the other hand, he would not have had to look far in order to see very harsh conditions close to where he lived; and he certainly did discover the impoverished conditions of the 'new East End' when he became acquainted with the St. George's district in Camberwell (close to Walworth and Peckham). It was here that Ernest - when he was not painting in such places as Scotland, Salisbury, Cornwall, and even France - involved himself in a range of voluntary roles among the young people.

London's East End became the classic down-trodden area where cockneys lived and slum followed slum for miles. But of course most large towns and cities across Britain had their own sad stories to tell, with their slum quarters and problems of high rents, crime, drunkenness, blind-alley jobs and unemployment.

Today St. George's Church in Wells Way, Camberwell still stands, not as a functioning church but as a shell for bricked-off apartments. The Greek revival building of 1822 survived being deconsecrated until 1970 (a new, smaller church and centre was built not far away in the 1980s). The Surrey Canal, too, has long since been grassed or built over. But the majesty of St. George's and the optimism of spreading the Word of God among the rather well-heeled flock in the first quarter of the nineteenth century seemed always destined for defeat rather than success. The ambitious building, with a 2000 seating capacity, stood by (and rarely full) as the better-off gradually moved away while the poorer classes migrated in. It was quite an astonishing movement of people: the 1841 census recorded 40,000 inhabitants, sixty years later it had risen to 260,000.

Local social observer and recorder W H Blanche described the changing face of St. George's and parish in 1875:

Originally built among green fields, with a windmill, the very sign of country life, close to its graveyard, it now stands among houses packed in those close rows which almost seem to keep out the free air of heaven from their inhabitants.

Unsurprisingly, by 1885 a mission was started in the parish (and in 1891 that same Prince of Wales who had begun his officiating duties by opening the Art School in Lambeth, opened the new mission building in nearby Albany Road). Oxford had taken the lead in the Mission Settlement movement, notably establishing Toynbee Hall in Whitechapel in 1885 - the model on which most other settlements were based. The aristocratic (but very down-to-earth) Roland Philipps gained his first experiences in mission work at Oxford House and Toynbee Hall. Trinity College had decided to do work south of the Thames and wanted to come to the rescue of those in south-east London. The choice of Camberwell was partly through the St. George's vicar being a Trinity man (it would be Cambridge's largest mission though not the first, other Cambridge colleges had already begun setting up mission centres in other parts of south London).

Another reason for the St. George's parish being chosen by Trinity lay, strangely, closer to home. The vicar at St. Mark's, Kennington, the Revd. H H Montgomery (and father of the future Field-Marshal), was approached for suggestions and, whilst not wanting to hand over any part of his own parish, commended parts of the St. George's parish which lay near Camberwell Road.

As far as Ernest is concerned, perhaps it was his uncle, the Revd. E S Carlos, who first brought the St. George's Mission to his attention. Trinity College was his uncle's former college, and the Revd. E S Carlos is recorded among the long list of subscribers to the £7000 Building Fund of 1890. In that year, of course, Ernest would only have been seven years old, but from the early years of the new century it is known that Ernest helped out with rummage sales, the Band of Hope and with putting on shows. It is doubtful whether he could always offer a weekly commitment, yet the mission halls in Albany Road and New Church Road were so large and diverse that they always needed as much voluntary help as possible, no matter how much or how little individuals could offer. Charles Booth's social inquiry of 1902 tells us that the St. George's missionary work included 1800 children in its Sunday Schools, 300 in its Band of Hope, and 400 older boys and girls in its Bible classes. It also had seven separate choirs, day schools and employed three full-time nurses.

Photos overleaf: Views of St. George's Church, ancient and modern.

Also (page 68), although not its original home, the Camberwell Beauty mosaic can be seen on the side of Lynn Boxing Club, adjacent to St. George's Church, Wells Way.
.

ST GEORGE, CAMBERWELL, SURREY.

The hymn tune *Camberwell* was written by Michael Brierley. It was dedicated to first vicar of St. George's, the Revd. Geoffrey Beaumont.

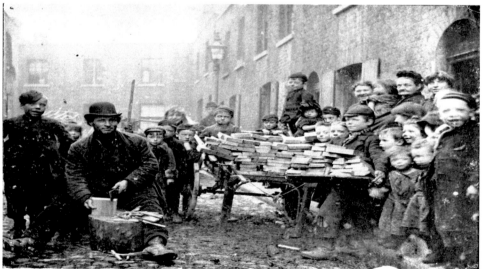

Above: Poverty in Southwark's Tisdall Place, *c.* 1890s. Look carefully and you will see that the gentleman may not have been a natural left-hander!

The Camberwell Beauty was first sighted in Britain in 1748, in the green fields of Coldharbour Lane, Camberwell. The mosaic seen here on the side of a former public wash-house (in Wells Way), was originally on the wall of print merchants Samuel Jones and Co., in Southampton Way.

Below: The Hon. Roland Philipps (later a captain during the Great War, where he fell in 1916). The Stepney Scout settlement named after him, although a private residence today, can still be recognised. Notably because it still has a flag pole attached and the private apartments at the rear are in what was later named Roland Mews.

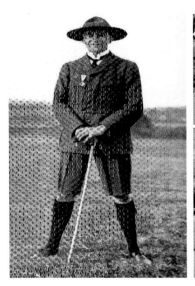

A GRADUAL CHANGE OF DIRECTION

In the available sources, Ernest is always spoken highly of. He was never too proud to help out wherever he could be of use. And by getting involved, of course, this must have afforded him ample opportunity to meet and compare the overcrowded life of impoverished families with his own upbringing. Moreover, the class of boys attending the Bishop School camps in Salisbury, and the well-to-do sitters - young and old - who formed much of his clientele and whom he visited in their grand homes (or even castles and palaces - see page 70) gave further food for thought.

Ernest's dual life helps to explain the juxtaposition of regular portraiture with subject material that was becoming closer to his own heart. He might have always hoped but could never have predicted just how favourably his Scout paintings would catch the imagination and appeal of those in or connected with the Scout movement.

One has to remember, too, that the typical Scoutmaster in those pre-Great War years was unique and different to those who came after - the first boys and men in the movement were pioneers in a very modern (yet traditional in other ways) and exciting youth movement. The Scout movement of 1908-14 took the country by storm. It was a new boys' movement founded by a charismatic national hero: Robert Baden-Powell (at this time not quite a Sir, and he'd have to wait until 1929 before being made a Lord). It was immensely popular with adults because it ticked so many boxes, particularly its character training and moral framework. Boys loved it because its founder was the David Beckham of his day, it had a quirky uniform with plenty of add-ons, and the captivating writing in the manual *Scouting for Boys* (a handbook not a rule book) offered escapism and alternatives to humdrum home, school, work and street life.

Importantly, many of the earliest Scoutmasters saw their role as a call to arms in serving and guiding the young. To them, being a Scoutmaster was a vocation; commendably, they wanted to keep working-class boys on the straight and narrow: keep boys in school or guide them into good trades; steer them away from cigarettes, alcohol, gangs and 'loafing'. Additionally, they wanted to improve each boy's self-worth, give them a sense of pride in their community, country and empire. Whilst the Boy Scout's motto was Be Prepared (conveniently using the initials of its founder), the unwritten motto in *Scouting for Boys* was Country First, Self Second. The 'sacrifice is a wonderful thing' ideology of so many of Ernest's and Roland Philipps' generation was incredibly strong yet seemed curiously odd to later generations. Having seen the personal letters sent home from the Front by Roland Philipps, it's hard to understand how he could write in terms that suggested the war was a wonderful thing and that he almost couldn't wait for his glorious end to come. That said, perhaps he was aware, like many others, that private letters could serve as propaganda or that his real feelings wouldn't get past the censor. When Baden-Powell wrote to Ernest's mother soon after he was killed, he described her son's ending as a 'splendid death'.

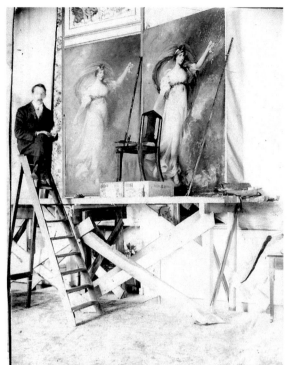

No doubt the artist initially enjoyed the travelling and occasional challenges. In 1906 he went to Paris to paint a copy of the portrait of Catherine II of Russia for the Countess Bobinsky. Also in 1906, as seen here, he visited Inverary Castle on Scotland's west coast to paint a copy of a Hoppner painting for the Duke of Argyll. At a later date he supplied the Duke with a copy of a portrait of HRH Princess Louise.

(Inverary Castle was used as the setting for ITV's 2012 Christmas episode of *Downton Abbey*.)

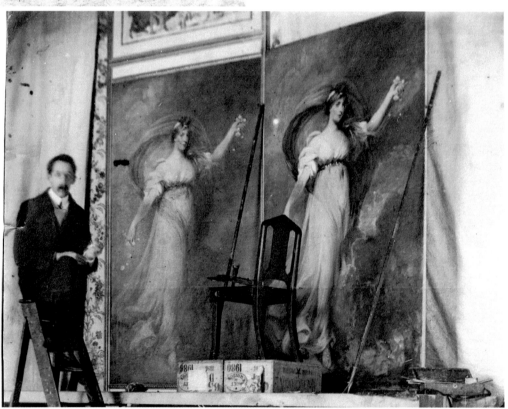

Such commissions opened both his eyes and employment corridors for Ernest. But after a time, the travelling may have become more onerous and the demand for copies a restrictive pursuit. Whilst mixing with people from a higher social class than his own may have had some fascination, the true artist in him wanted to portray those who had far less representation in society.

NEVER AGAIN.

To the Editor of the "Daily Mail."

Sir,—I am one of the "rejected" of the Royal Academy. I am sure it must be disappointing to those who, like myself, have spent a long time in thought, labour, etc., to bring their work up to a high standard and then—getting it "thrown." I for one have vowed not to send to the R. A. again, and I wish others would do the same. Surely something could be organised for those who would stand off from the preserves of Burlington House.　　　　CONSISTENT.

These images were collected by Ernest. They hint that not everything was rosy, and perhaps throw light on the double-edged sword nature of submitting paintings for exhibitions. I am not sure if he was the author of the letter to the *Daily Mail* (*c.* 1909); if not, presumably he concurred with its contents.

Ernest's Scout paintings seemed to captivate so many who saw them. Whilst the Scout movement was quite good at self-promotion - it had what today would be called a PR department but was then known as the 'propaganda department' - its lantern slides and sets of publicity postcards were rather repetitive, contrived products. Large colour oil paintings, on the other hand, where the subjects were not starchily posed, even when reproduced as colour prints really reached out to people. Ernest's *The Pathfinder* painting proved to be a significant publicity tool for the movement. It is forgotten now just how quickly and widely the *Pathfinder* image circulated the Scouting world (by the late 1920s there were over four million Scouts and Guides worldwide). From the early 1920s there were few Scout halls across Britain - and in many premises overseas too - which did not have a framed print of *The Pathfinder* on its wall. *The Pathfinder* and other Carlos Scout paintings were also widely and frequently used in postcards and Christmas cards, books, diaries, magazines, and to advertise anything from jumble sales to AGMs.

Roland Philipps himself saw Ernest's painting *If I were a boy again* at the 1913 Birmingham Scout rally/exhibition and couldn't resist putting in an offer. Philipps was the son of the wealthy and influential Viscount St. Davids. Perhaps it was partly Roland's imminent purchasing of 29 Stepney Green in East London that over-stretched his funds, as correspondence in the Scout Association's archive reveal that he was rather slow in coughing up! He got his picture, nonetheless, and it hung for many decades at 29 Stepney Green. (The house was used as a home and district Scout headquarters; it was named Roland House after he was killed during the First World War, and became a Scout hostel/settlement for leaders in the Scout movement working and studying in London. It was finally closed and sold in 1982.)

Although young, Roland held several key positions in the movement and became a personal friend of the Baden-Powell family (and Philipps, like many of his ilk, idolised 'B-P'). The correspondence over Ernest's paintings suggests that they may not have actually met face to face but had a great deal of mutual respect for one another (and it has to be remembered that Ernest - as far as is known - did not become a uniformed member of the movement until *c*.1914).

A sign of Ernest's kindness can be seen in the fact that he happily loaned his new painting *If I were a boy again* for a fundraising exhibition organised by South London Scouts. It was loaned exclusively for that purpose to a Scout Troop attached to St. John the Evangelist Church, Angell Town. This Brixton church was the sponsor for several of his brothers' early education at St. John's School (and the parish magazines show that Ernest was still in touch with the church when an adult). The South London Scout Exhibition of late 1911 was an ambitious publicity ploy held over several days. In addition to Baden-Powell attending for one of the formal openings, it attracted some well-known personalities on other days. The array of sights and activities included Scout-made items for sale, demonstrations and exhibitions in such things as basket-work, music, wrestling and boxing. A Walworth champion, 'Snowball', was one of the judges. And there was even a chance for people to have their bodies x-rayed (courtesy of equipment loaned by a local hospital). Intriguingly, the Scouts' national magazine - the *Headquarters Gazette* - mentions that a 'Scoutmaster artist' had designed the diplomas which were to be awarded to successful Scouts in the various competitions.

Ernest had generously loaned his original painting to the Troop though perhaps at that time he had less of an inkling as to how popular his Scout paintings would become (was he testing the water with his first Scout painting?). He soon after began to enjoy at least some remuneration from reproduction fees. This was the case when an image of *If I were a boy again* was reproduced in a widely published church magazine (and *The Pathfinder* was copyrighted in 1914). Such evidence suggests that Ernest by this time was fairly comfortably off, though it seems that he did not live an extravagant life. No doubt he had to contribute to the running of the family home, and by this time his father had taken early retirement. Soon after Ernest's death, all his money and effects - as per his wishes - went to his mother, which amounted to around £2,600.

Below: A photo of Ernest's first main Scout painting taken at the White House, Gilwell Park. Titled *If I were a boy again*, it was painted in 1911 and exhibited at the RA. Ernest had wanted it to be part of the Boy Scouts' wedding gift to Baden-Powell (who married the very young Olave Soames in October 1912).

42, Foxley Road,
N. Brixton,
S.W.

February 10th, 1913.

Dear Sir,

10 FEB 1913

I am afraid you found my Scout picture 'If I were a Boy again' very heavy for hanging as I had it glazed for protection against any smoke or dirt.

If there is any difficulty in hanging it please let me know and I will send my man down.

It is very kind of you to let the picture hang at the headquarters.

I remain,

yours faithfully

Ernest S. Carlos

E. Cameron Esq.
 Secretary,
 The Boy Scouts' Headquarters,
 116 Victoria Street,
 S.W.

118821
S.

30th June 1913.

The Honble. Roland Phillips,
 The Grand Hotel,
 BIRMINGHAM.

My Dear Roland,

I received a letter from Mr. Carlos stating that he is very pleased to accept your offer of £65 for his picture, "If I were a Boy Again".

The picture is therefore now your's, but I should be glad to know if you would like it to be hung in this office until have have a place to put it?

Yours sincerely,

Some of numerous letters kept by the Scout Association concerning Ernest's Scout paintings. In one (not included here), for example, we learn that one painting was insured by Harrods whilst on show at the Birmingham Scout rally.

The Hon. Roland Phillips,
 University House,
 Bethnal Green,
 N.E.

Dear Roland:-

Mr. Carlos has written me a very nice letter reminding me that he has not been paid for his picture which you remember you bought some time ago. He wrote in case there might be some mistake.

He is a poor man and if you could raise the cash it would, I believe, be very welcome.

Yours sincerely,

Left: 'poor' is relative!

74

Boy Scout images taken from Ernest's sketch book.

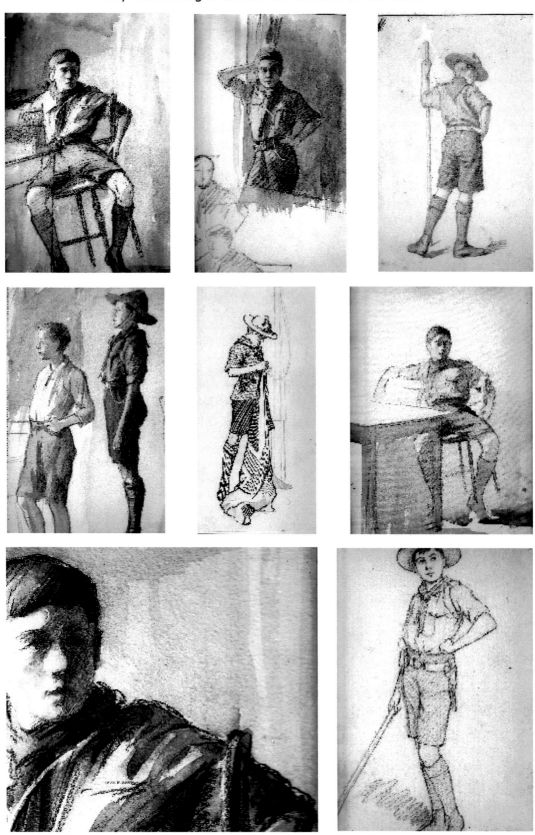

Author and biographer of Baden-Powell, Tim Jeal, gives an interpretation of Ernest's first main painting with a Boy Scout theme: *If I were a boy again*. He refers to Baden-Powell as 'Stephe', which is how he was frequently known by those closest to him as a boy and young man (it should be borne in mind that Carlos wasn't actually a Scoutmaster or member of the movement in 1911):

The supposed innocence of boyhood, and nostalgia for it, would one day become an obsession with many male Edwardians. One of Stephe's favourite paintings was by a South London Scoutmaster called Ernest S Carlos. Painted in 1911 and entitled If I were a boy again, *it depicts an attractive optimistic boy in Scout uniform about to go out and enjoy a day of healthy outdoor pursuits, and after it a purposeful life. Not so the boy's broken-looking father, who is slumped at a table and is plainly not going outside or anywhere else. As he gazes at his son, he seems to be mouthing the words of the painting's title.*

Jeal also tells us that Baden-Powell used the image for publicity pamphlets, where he urged men to join the Movement: *As Scoutmasters, he promised that they would be able to 'renew their youth' as 'Boy-Men'.*

Below: *Be Prepared* (1912 - Ernest dedicated it to Baden-Powell). So more relaxed and natural than many officially published photos of the time. Although the subjects and props have been carefully posed for the painting, the artist manages to capture a scene of real Boy Scouts in the middle of doing something. The workaday uniform and attitude of the boys, especially the Scout hat on the floor, would not have been accepted for an official publicity photo by the Boy Scouts Association. The Scoutmaster was the locally well-known Maurice Gamon. He lived off the Waterloo Road and ran the Wellington Troop.

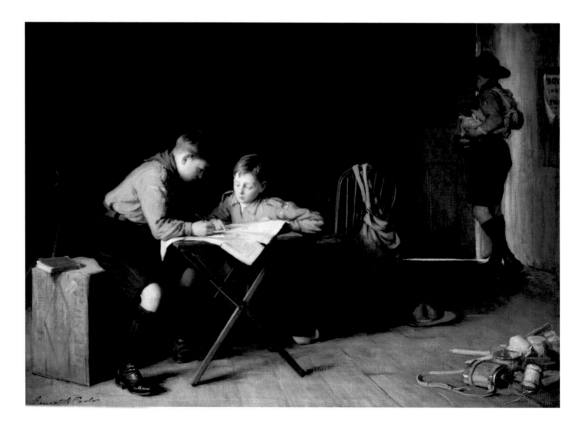

THE YOUNG SITTERS FOR ERNEST'S SCOUT PAINTINGS

For many decades the identities of the sitters in Ernest's Scout paintings remained a mystery. Circumstances changed somewhat in the 1970s and later when a few elderly gentlemen began to communicate with the archives department of the Scout Association. Some were no longer local, one had moved as far as Australia, and the distance of sixty years or so made reminiscing rather challenging. Human memory, as it is prone to do, could not remember all the details, it left some out, put others in a different order and, possibly, attached memories relating to other people and incidents on to non-related stories. The fact that Ernest had five brothers - all with similar features and, even when in their twenties and thirties, nearly all living at the same address - probably also added to the confusion. That said, with memories from different sources, the partly corroborated contributions from these past members of the Scout movement have helped considerably in filling in gaps and giving us a real insight into Ernest's character.

Syd Flood wrote to the Scout Association's archivist in 1974. He helps to fill in on the Carlos household. The Carlos 'boys' were obviously both very close and active:

I first met Ernie in about 1905, when I would have been 6 years old. He called on my mother and asked to borrow me as a model. He was painting a child (I seem to remember it was the son of the organist of Salisbury Cathedral) and wanted me to wear a silk blouse, so that he could finish the painting. He used to call for me and bring me home.

The Carlos family consisted then of both parents and 6 sons and 1 daughter. The Revd. Jack, George, Ernie, Sid (B.Sc.), twins Ted (ARCO) and Bob, and Nina, all living at 42 Foxley Road, SW9, in the garden of which was a very large wooden building (on wheels to avoid rats!) which was the studio. The family were, I think, of Spanish extract and they had a coat of arms on their wall, depicting King Charles in an oak tree; an ancestor is supposed to have hidden the King there.

My next memory is, as a lad of say 12, going with the Carlos men, on cycles, to Lambeth Swimming Baths, at 7 a.m. every Saturday morning, with a group of other boys.

Ernie joined the Army in 1915 [actually 1916] *and I remember seeing from time to time his humorous black and white drawings of army life on his postcards to home…*

Ernie was a tall, loosely built man, with a long easy stride. He never seemed to be in a hurry and had a wonderful sense of humour. He ran side shows at the Annual Sale at St. John the Divine, Kennington, his parish church and one I remember was 'Pay 1d. and see the Great Waser (sic)'. *Inside the curtains, was a broom with only a couple of hairs (it was a broom). He ran a competition to see who could make the best butterfly, by putting three dabs of oil paint on a piece of paper and then folding it over and lightly pressing it.*

The two boys on his Scout pictures were both choir boys at St. John's: Percy Greaves in Be Prepared *and a red head, Bob Blackett in* If I were a boy again. *The two boys were easily recognisable in the picture. (Blackett is in Australia and came to see me when on leave about 15 years ago.)*

Other pictures I saw in his studio were: Bishop Hook, Bishop of Kingston and Canon Brooke of St. John's. Also a wonderful self-portrait of Ernie, holding a palette and sucking the end of his brush.

The second extract is from a letter sent to the Scout Association's archivist from Bob Blackett in November 1984 (who had emigrated to Australia after the First World War).

In my youth I was a choir boy at St. John the Divine, Vassall Road, Kennington, and in those days, to be in the choir you had to attend the church school in Camberwell New Road, which was almost opposite the entrance to Vassall Road.

I would be a little over 14 years when a boy named George Wild told me that an artist wanted a boy with red hair and a Scout uniform to be a model for a picture he was painting. As I had both, I got the job.

He (the artist) lived in Foxley Road ... I feel sure the studio was in the garden behind the residence.

We used to sit during afternoons. He would pay us 2d. an hour and during the period one of us would go out to buy some buns and we would share them with a cup of tea.

The painting I was in was called Headquarters [later renamed *Be Prepared*, shown on page 76] - *we were supposed to be preparing for a camping trip.*

The map displayed was of South West England and, to keep up our interest, E.S.C. would ask us to find the situation of certain places he mentioned.

There would be different claims as to who had posed for which picture over the years (with occasional false claims too). Perhaps the sitters were not aware that the artist may well have used more than one sitter for the same painting. Bob Blackett's family, writing from Camberwell (Camberwell Australia!) believe that for the painting *Headquarters*, Bob was definitely used, and there could be no doubt about the legs in the picture!

Interestingly, for Ernest's most widely known Scout painting, *The Pathfinder*, the boy who is said to have posed for it - Percy Greaves - was not known to be a Scout at all. The painting, which was reproduced in various forms (and later in numerous stained glass windows), did so much to promote the movement over the early decades.

Said to be rather aloof, both Percy Greaves's father and grandfather were hot water engineers, but Percy's entry in the St. John the Divine choir register shows he moved address on at least three occasions. Although the family were long associated with St. Michael's of nearby Stockwell, it would seem that he did not have a particularly stable home life and therefore perhaps not much time or money for such things as Scouting. Born in 1900, by the time of the 1911 census he and his mother are recorded as living in the home of his grandmother. Percy's dad is recorded as being a commercial traveller in ironmongery and living with a widow and her seven year old daughter in Finsbury Park.

Above: Entries in the choir register. Percy eventually suffered the fate of all choir boys - his voice broke - but not until he was fifteen years of age.

The genre Ernest used for *The Pathfinder* was more common than we may realise; he would have seen plenty of paintings that used youthful individuals with Christ, angels, haloed figures and/or spiritual guides. Nonetheless, Ernest was still able to put his own stamp on it and produce something that was both topical and captivating.

Although Ernest did not actually found a Scout Troop of his own until around 1914, we know that he was already very familiar with the movement. In his *Pathfinder* painting, we can see that his chosen Scout has three service stars, several proficiency badges and the two white pocket stripes tell us he is a Patrol Leader. As per B-P's wishes, the Scout has his shirt sleeves rolled up: a sign that he is prepared, ready for action, work… Ernest also knew that B-P liked to see sleeves rolled up on the inside because it looked smarter. Lastly, the scarf has a knot in it to remind the Boy Scout to do his daily good turn (doing something for nothing - it proved to have wonderful PR value for the movement).

The images below and overleaf are of a *Pathfinder* window originally installed in Erdington Baptist Church, Birmingham in 1930. When the church was pulled down and another built, the window lay in store, forgotten about for many years. Unusually, some of the glass is over 300 years old and originates from St. George's Chapel, Windsor. In the late 1960s it was restored and put on display in the new church building (at Erdington Six Ways Baptist Church, where it can still be seen).

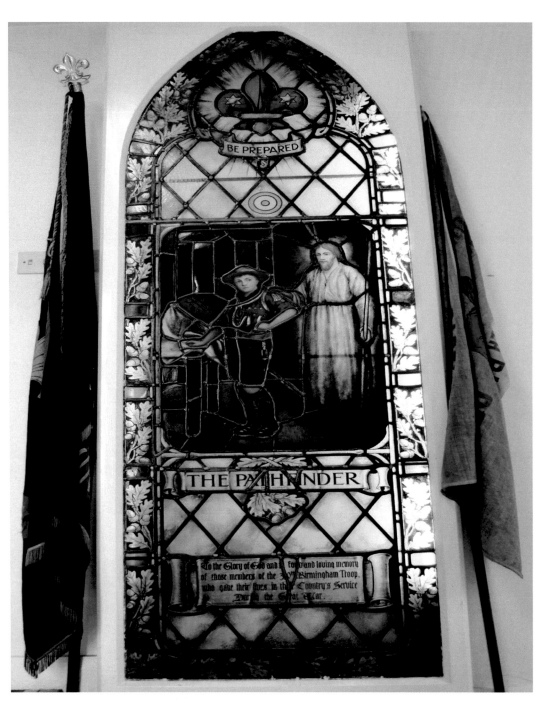

BE PREPARED

THE PATHFINDER

To the Glory of God and in proud and loving memory
of those members of the 30th Birmingham Troop,
who gave their lives in their Country's Service
During the Great War.

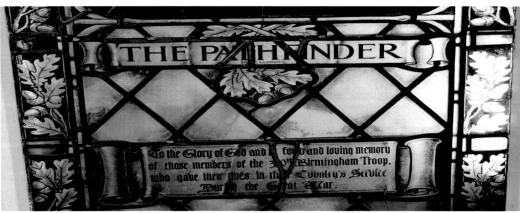

THE PATHFINDER

To the Glory of God and in proud and loving memory
of those members of the 30th Birmingham Troop,
who gave their lives in their Country's Service
During the Great War.

For the uninitiated, the Boy Scout of 1913 was a walking SAS man, AA patrolman, junior doctor, spy, cowboy and full-time hero. Some exaggeration on my part, but the Boy Scout, armed with Baden-Powell's legendary tips and anecdotes from *Scouting for Boys*, had a uniform and new persona, cleverly designed to help the boy elevate himself, enabling the boy in turn to help his community, country and empire.

We have to remember that in the period 1908 - 1914 there were no other branches in Scouting (apart from a newly emerging Sea Scout section) - no Wolf Cubs or Rovers - in practice, the Boy Scouts were an exclusive organisation that catered for youths aged anywhere between 11 (10 unofficially) and 18. Indeed, the various proficiency badges were designed to give a boy a taster and then training in a craft or trade, to help him know what he might be suited for when it was time to seek employment. Should he need a letter of reference, it was often the Scoutmaster he turned to. In addition to the Boy Scout's unique handshake (always with the left hand), and unique way of tying his laces, the uniform components had special uses, some of which are listed in the box below.

The hat, sometimes called a 'lemon squeezer', it was also known as the B-P hat, one Scouting's founder used to wear as a soldier (though B-P actually stood for its name and design: *Boss of the Plains*). It could be used to keep the sun or rain off, but also for collecting water or feeding a horse. Later, thousands of Scouts used it for fanning fires or as goal posts!

The Scout's staff could keep hostile crowds back, aid when vaulting over walls, be inserted into overcoats to make stretchers; alternatively, they could be used to swash bracken back or to check the height of trees or width and depth of rivers (they were marked off in feet and inches).

The scarf could be tied over the mouth to keep out dust and smoke, it made a good triangular bandage, handkerchief, water filter…

The garter tabs were small pieces of material with which to make repairs to torn clothing.

Other accessories included the leather pouch, compass, water bottle, lanyard, pen/jack knife and a belt buckle that served as a bottle opener.

Although the stained glass windows that can be seen in churches across Britain (numbering at least nine) vary in quality and accuracy - admittedly some were not intended to be faithful reproductions - the images overleaf and elsewhere show that even Ernest himself left out or else altered minor details from copy to copy. This and other aspects of *The Pathfinder* are discussed further from page 111.

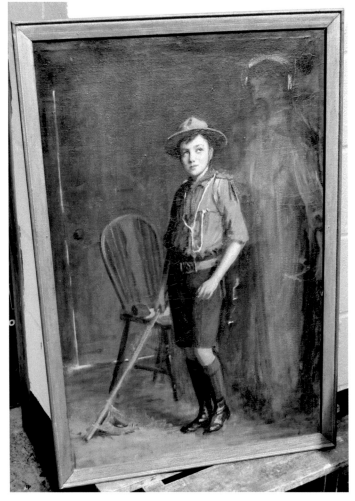

This first image (smaller than the others), still owned by the Carlos family, was always known as a preliminary study. It has minor damage but one can also see that it lacks the finish seen in the versions that followed. The familiar table (one that first appeared in *If I were a boy again*) has been replaced with a chair.

Small variations to watch out for in other *Pathfinders* include: the absence of a hat/chin strap; no Scout badge on the hat; where the hand is placed; missing belt pouch; an ironed crease in the shorts; a handle higher up on the door; the Scout holding a pen or not.

Right: A cropped and enlarged copy of this can be seen on page 113. It was no doubt a good idea to take the picture out into natural sunlight, I wonder if he made many changes?

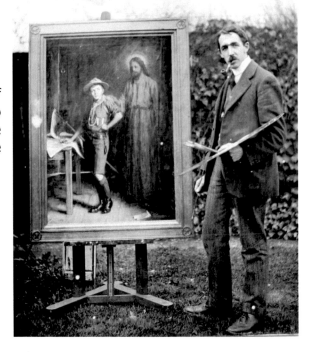

Below: On the left is the Scout Association's *Pathfinder*, often considered to be the original. It can be seen at Gilwell Park. It was sold at least twice before coming into the Scout Association's ownership. It came into the movement after a careful approach was made for Roland Philipps to buy it for the movement. During the war, he was serving at the time of its purchase in March 1916, but it was his two cheques of £60.00 and £40.00 that returned *The Pathfinder* to the Scouts, where it was first hung in the Scout Club at Headquarters. (They moved from Victoria Street to new buildings in Buckingham Palace Road in 1917, where they remained until 1974.) Headquarters first heard of Ernest's death in the same week they moved from Victoria Street. *The Pathfinder*, for many decades, had pride of place in the entrance hall at 25 Buckingham Palace Road. Having cost Philipps £100, the monetary value of *The Pathfinder* had doubled in just three years. To give an idea of prices in 1913, the Gamages Christmas catalogue was advertising: boys' bicycles for £5.5s, good upright pianos for 20 guineas, 18 carat gold rings with 11 small diamonds for £20.00 and a good quality full sized billiard table for £50.00. I'm not sure whether Roland Philipps ever got to see it again, he was killed in action going over the top on 7th July 1916. A conservative value for *The Pathfinder* today is £8,000.

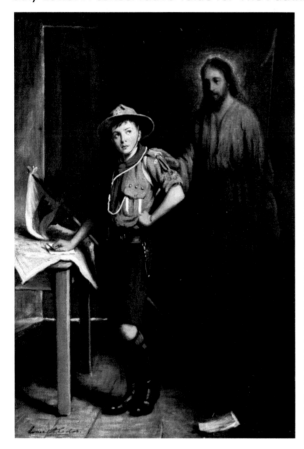

Below right: What a remarkable copyist Ernest was. This *Pathfinder* (signed just like the other one) belonged to the late Viscount St. Davids, and is still in the Philipps family today. It was always said in the family that the Boy Scout in the painting was based on Roland Philipps as a boy.

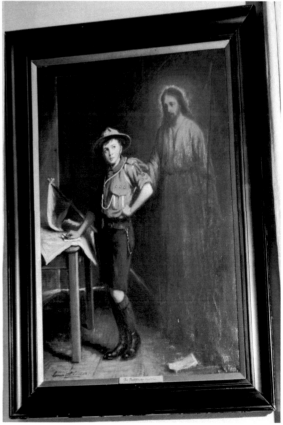

The temporary Holy Cross Church before its grander replacement. The brother of Ernest, the Revd. John Buckler Carlos, was first vicar here (1926 - 1945). In 1933, a year before the death of Ernest's mother, a memorial window was unveiled.

The window was unveiled at Holy Cross Church (Hornchurch) on 16th September by L H Tatham. I am not sure what Ernest would have made of L H Tatham's position as the Chairman of the Society for the Promotion of Duty and Discipline.

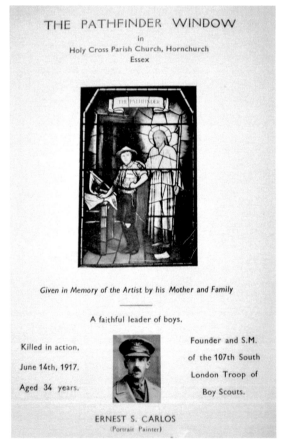

THE PATHFINDER WINDOW
in
Holy Cross Parish Church, Hornchurch
Essex

Given in Memory of the Artist by his Mother and Family

A faithful leader of boys.

Killed in action, Founder and S.M.

June 14th, 1917. of the 107th South

Aged 34 years. London Troop of

 Boy Scouts.

ERNEST S. CARLOS
(Portrait Painter)

DUTY CALLS

The dug-outs have been nearly all blown in, the wire entanglements are a wreck, and in among the chaos of twisted iron and splintered timber and shapeless earth are the fleshless, blackened bones of simple men who poured out their red, sweet wine of youth unknowing, for nothing more tangible than Honour or their Country's Glory or another's Lust of Power. Let him who thinks War is a glorious, golden thing, who loves to roll forth stirring words of exhortation, invoking Honour and Praise and Valour and Love of Country with as thoughtless and fervid a faith as inspired the priests of Baal to call on their own slumbering deity, let him but look at a little pile of sodden grey rags that cover half a skull and a shin-bone and what might have been Its ribs, or at this skeleton lying on its side, resting half crouching as it fell, perfect but that it is headless, and with the tattered clothing still draped round it...

The above is taken from author and feminist Vera Brittain's *Testament of Youth*. The mother of Shirley Williams MP, Brittain lost her brother and fiancé in the war, not to mention other close friends. Hailing from rural Buxton, she came down to Camberwell and trained there as a VAD nurse at the 1st London General Hospital before serving as a nurse overseas and near the Front.

From 1911 to 1914 Ernest had averaged one significant Scout painting a year. 1914 is also thought be the year he founded his own Scout Troop. This was done with the help of brother John (at this time changing from being an assistant schoolmaster to a curate in East Ham). Brother Arthur, too (shown below with Ernest), was known to help out with activities and camps. The Carlos Troop of 1914 still operates today as the 21st Camberwell (Trinity) Scout Group, based at the new St. George's Church.

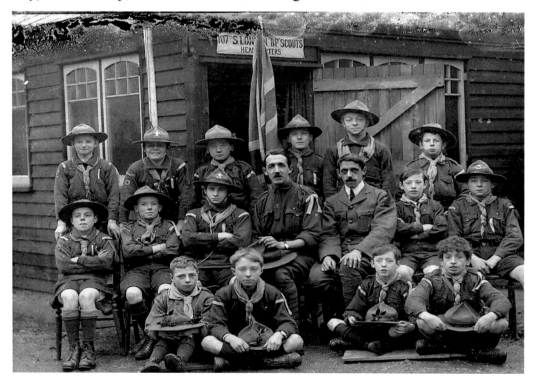

The photo of Ernest's Troop on page 85 shows that it was registered as the 107th South London Troop. Actually it was not a St. George's or Trinity Troop then, as they already had a Scout Troop (the 105th South London), but the St. George's Troop struggled during the war and eventually folded. Post-war, it was Ernest's Troop who were based at St. George's and who took on the Trinity title.

Back in August 1914, many Scout camps were cut short. Indeed, some boys arrived home to find older brothers, if not fathers, were already absent. They had gone to war. A war that would all be over by Christmas…

The relentless progress of the war, not to mention the advantage of hindsight, altered soldiers' and civilians' outlook immeasurably. Soon after the outbreak of war, newspapers and parish magazines were increasingly filled with war news, and notably - and very proudly - names of people who had enlisted (posters everywhere and the embarrassment of having a white feather thrust into your hand had helped recruitment considerably). Local papers and church magazines hinted at disappointment and frustration when Scout Troops had to struggle on without Scoutmasters, but the call to arms was celebrated: honour and duty were paramount. Although some Scout Troops struggled, many continued with Patrol Leaders stepping up to the plate (the period also saw a rise in an emerging species, the 'Lady Scoutmaster'). Indeed, membership of the Scouts increased because there was considerable kudos for boys doing 'real' war work in the Scouts. Thousands joined to help guard reservoirs, telephone lines, watch the coast, collect salvage and run messages for the police and town hall officials.

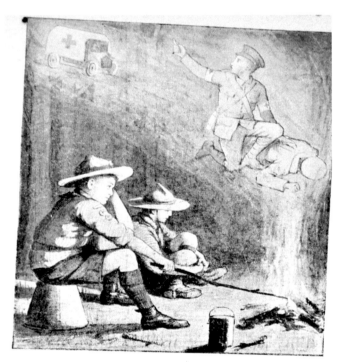

"OUR BOYS SHALL HAVE VISIONS."

THE PROCEEDS OF THE SALE OF THESE
CARDS WILL GO TOWARDS THE

Boy Scouts' Motor Ambulance Fund.

Later, increasingly long lists of wounded, missing and killed only seemed to make the demand for more men, both young and not so young, to answer the call even more urgent. Ernest had not avoided volunteering, he'd done this in 1914 but was rejected on medical grounds (despite being a little over the age for Kitchener's initial volunteers, which was 19 - 30). Thus he continued with his Scouting (Bob Blackett, one of his sitters who had been attached to the 1st Herne Hill, briefly transferred to Ernest's Troop).

Whilst Ernest did continue with some painting at this time, he began also to do paintings and sketches to help raise funds for such things as the Boy Scouts' Ambulance appeal (shown on page 86) and the Soldiers' and Sailors' Families Relief Fund. He may have helped the Church Army too. There is little doubt that he continued with supporting the social work of St. George's parish, and worked more closely with Trinity College's Cambridge House, which was just off the Camberwell Road, in Addington Square.

The mission/settlement centre that Ernest knew well still retains its Cambridge name; it operates today, giving support and legal advice to local people.

Overleaf: We shall read about Ernest applying again to serve his country, but this photo shows his twin brothers, Ted and Bob. They served as motorcycle despatch riders in the Notts Hussars (and their mother thought it very unfair that both should be called up). Ted was called up first. A family tale is told where the likeness was used to advantage. If Ted wanted to play the organ at weekends and couldn't get leave, Bob - although not yet serving - would swap places with him at the barracks. Other family members and friends found it strange that if they started a conversation with one of the brothers inside the house, if they went outside, the other brother waiting outside would continue the conversation.

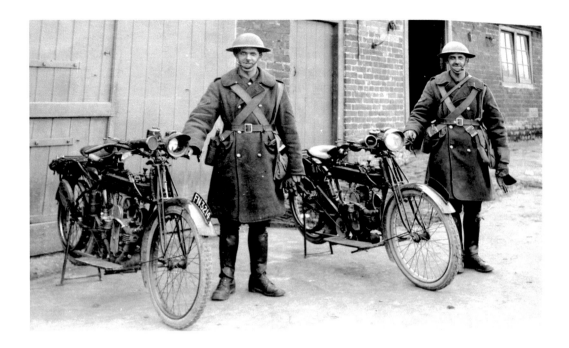

Below: Brave smiles? Perhaps not a natural soldier but he had a great sense of what was right. No doubt his brother - now the Revd. John Carlos - was getting used to his new dog collar.

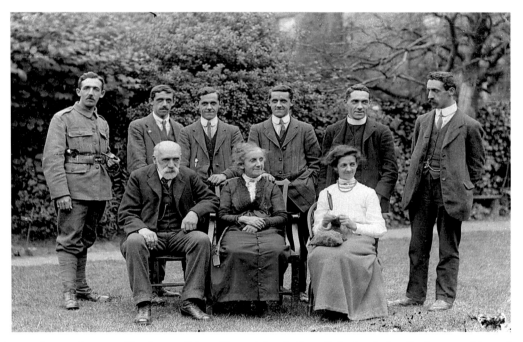

It is unclear what medical condition Ernest had. Possibly he inherited something from his father, who retired early. In photos of John Gregory in later life, he is seen with a stick and has a slightly hunched appearance (both were pipe smokers). He died in 1919, aged 69, the death certificate recording: myocardial degeneration, bronchitis and cardiac failure.

It is surprising that Ernest did not apply to the Artists' Rifles Brigade (28th Battalion

London Regiment), which had a recruiting office off the Euston Road. Although using the word Artists, the Brigade was generally also open to poets, musicians and even individuals from other professions. The Artists' Rifles already included such men as Wilfred Owen and Charles Sargeant Jagger (the latter being a close contemporary of Ernest's and one-time tutor at the Lambeth School of Art). Nonetheless, in 1916 Ernest volunteered again and was this time accepted as a private in the Queen's Westminster Rifles (the 16th Regiment).

He spent a short period abroad, where he got plenty of training if not much action. Like many, by this time he viewed the war as a nuisance but felt that every man should help to the utmost so that it could be finished as soon as possible. Upon his return to England he was posted to No.12 Officer Cadet Battalion at Newmarket. From here he was commissioned as a Second-Lieutenant to the Royal East Kent Regiment (known as The Buffs). Although a Kent regiment, his Battalion - the 8th - was known to have quite a few Londoners and men from south-east England.

Ernest joined his regiment in France in March 1917. Newly commissioned officers worked alongside more experienced ones, a few others were even veterans of the South African War. For the likes of Ernest, he may not have realised how vulnerable his inexperience made him. Seeing the turnover of officers and men, perhaps he did have an inkling of the statistics, hopefully not, as within three months he would be dead.

The Scout Association archives has in its collection a letter sent from Ernest while he was serving with The Buffs in France, it is simply dated 'Sunday'. It is Ernest replying to one of his Scouts (or possibly somebody running the Troop on his behalf). Transcribed below, it gives a flavour of Ernest's time there, along with his thoughts and newly acquired jargon. It is not of the 'Should the worse happen' variety, that was reserved for his senior brother (shown on page 92).

8th Battalion The Buffs
BEF
Sunday

Dear Crane

> *Thank you for your interesting letter & news of the Troop which I was very glad to get.*
> *I am now sitting beside a large barn in a field where we all slept last night, our tents are being put up but unless it rains we are not going to sleep in them. A Bosh aeroplane has just been over & our anti-aircraft guns have peppered the sky with shells but as far as I could see the wretched bosh got away. We are all longing for the war to be over & mean to do our best to end it as soon as possible.*
> *It is very hot & I am just baked so I think I will move into one of the tents.*

How is Nudder? Tell him *Your sincerest* [?]
to write to me next time. *Ernest S Carlos*

The war sketches Ernest did (see examples overleaf) remind us of the incongruity Ernest and others must have felt. Whilst giving us an idea of his and his Battalion's movements,

they also show the long periods of waiting and occasional humour sandwiched between heavy action and gruesome deaths. One minute there could be planes overhead and the rattle of guns going off, the next, the sound of peasants working in a field or soldiers having a kick about. Local army maps now reworked the area with names such as Mouse Trap Farm, Euston Road and Threadneedle Street. No doubt it was the humour and snatched opportunities to paint that helped Ernest keep his sanity (just too late for Ernest, in 1917 the government established a Department of Information that began commissioning artists to make a record of the war).

 'Steady The Buffs!' - This is the insignia of Ernest's regiment, originally formed in 1572 (absorbed into the Queen's Own in the 1960s).

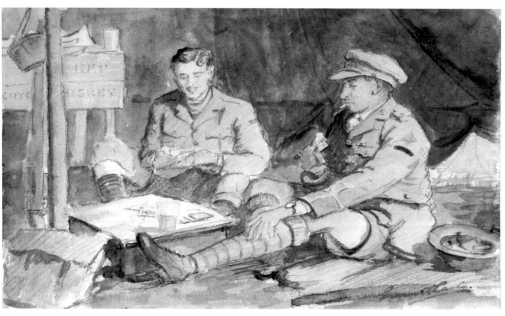

Back home, as early as 1914, Ernest's sister Nina was described as having a complete physical breakdown and was ordered to have six months rest (had she come down with something or had she lost a sweetheart, an early victim of the war?). What with talk of rationing, the threat of Zeppelin raids and the dearth of working men at home, in the same year as Ernest's enlistment, even his father came out of retirement and helped the war effort by becoming a manager at a local shell filling factory.

Meanwhile, Ernest wasn't stationary for long. Listening to gramophone records and playing cards ran alongside church parades and rehearsals for bombardments and gaining enemy territory. Entries in the Buffs' war diaries for the time give a flavour:

7.5.17
Fine day. Church parade in farm yard at 11 a.m. Few small shells between this field and [?] and some a few hundred yards N of farm.

No aircraft up during day owing to wind. Officers played 12th R. Scob at Rounders & beat them 2 to 1.

On the other hand, Ernest would have become increasingly aware of the sharp contrast of dull days and then heavy enemy fire and the seemingly here-today-gone-tomorrow nature of wartime fatalities. His last letter home to brother Jack (shown below and on the following pages) reveals his wartime altered attitude, for he wrote: '... if there is any killing done near me I hope to do it'. His already widely respected and known selfless nature hints at how his life and career path might have gone after the war - possibly much more down the route of practical Christianity. Sadly, he would be just another statistic hidden among the one million British and Commonwealth soldiers killed in World War One.

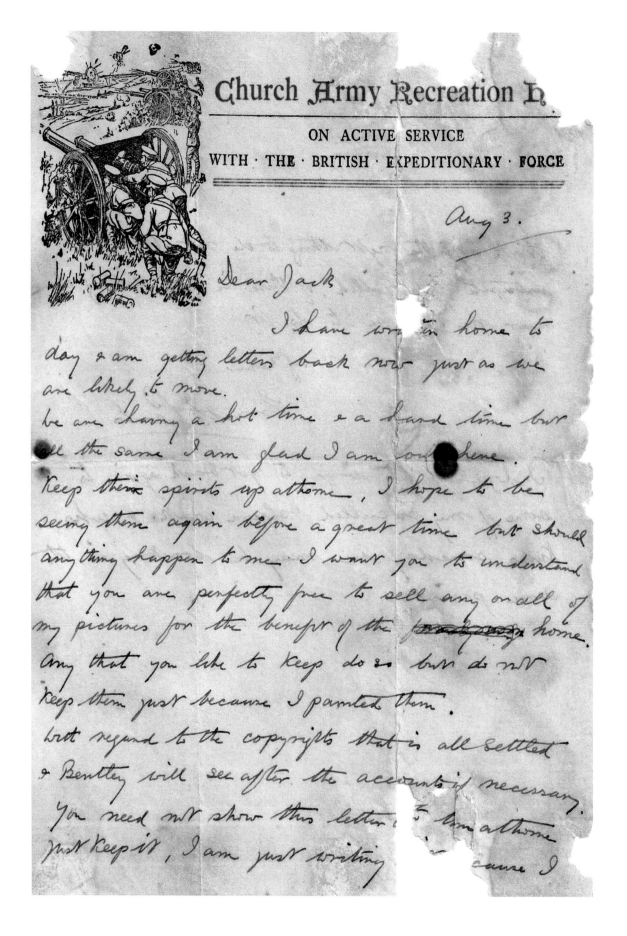

Church Army Recreation H

ON ACTIVE SERVICE
WITH · THE · BRITISH · EXPEDITIONARY · FORCE

Aug 3.

Dear Jack,

I have written home to day & am getting letters back now just as we are likely to move.

We are having a hot time & a hard time but all the same I am glad I am out here.

Keep their spirits up at home, I hope to be seeing them again before a great time but should anything happen to me I want you to understand that you are perfectly free to sell any or all of my pictures for the benefit of the ~~~~ home. Any that you like to keep do so but do not keep them just because I painted them.

With regard to the copyrights that is all settled & Bentley will see after the accounts if necessary.

You need not show this letter ~~ them at home just keep it, I am just writing ~~ cause I

think this is the right thing to do yet that I anticipate there killed, if there is any killing done near me I am to go to do it

yours [?]

Senator [?] Camb[?]

I hope after the war to get back again to ... done if my so called abrom work & who knows someday we may be working in the same period

Ernest was painting at least four days before his sudden death, as his last painting - *A Bivvy* - is dated 10th June 1917. He was only ten days past his thirty-fourth birthday when he was killed at a place called Buffs' Bank, by the canal in Battle Wood, Belgium. His life was snatched in the evening of 14th June 1917. He had been leading his platoon (XI platoon) in an attack when he was caught by shellfire. In the dark mayhem, his body had to be left among the flies, frogs, mice and rats until the next morning. Snatches of handwritten notes by survivors who were there and knew him are all the family have. One written to his mother soon after is thought to be by his friend Captain Rice (it is Captain Rice and 2nd Lt. Lilley who are depicted playing cards whilst in Poperinghe, near Ypres in Ernest's sketch on page 90). The account, which in places is not easy to decipher, states:

14th July 1917
Your son was killed whilst leading his platoon in a most gallant manner, in an attack made by the Battalion against the German position south of Ypres just by the right angled bend in the Ypres canal.

As we know, Ernest's body could not be recovered until the following morning. A chaplain wrote on 20th July 1917:

Mr Carlos was instantaneously killed by a shell. I was with the stretcher bearers that brought his body down from the line and we buried him in Chester House Farm Cemetery near Dickchurch. I searched his body for any letters or articles of value but the only thing I found was a compass on his wrist which was handed in to the Quarter Master to be packed up with his kit. A permanent cross has been erected on his grave by the Registration ... and a party of two or three men were [End of available extract].

In time, the temporary wooden cross was replaced with the stone one that exists today. Evidently unremembered and unseen for many decades, after much searching in Nunhead Cemetery (south-east London) I came across the overgrown Carlos family grave. It shows that Ernest's name was added to the family headstone (see photos on page 100).

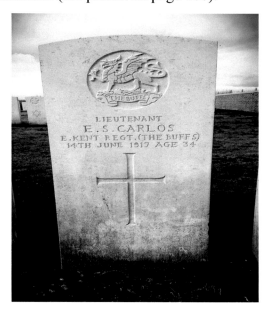

Chester Farm Cemetery, Zillebeke (about five miles south of the town Leper), Belgium. The cemetery was designed by Sir Edwin Landseer Lutyens.

Mrs. Wordsworth, the wife of the Bishop of Salisbury, wrote to Ernest's mother after his death: *It seems to me utterly wrong that such a man as he was should be a soldier. We cannot afford to lose these gentle, high, fine natures, who did so much by their gentle kindness and understanding to help everyone to make this world a better place. He did this always, in a remarkable way.*

In contrast, veteran of the Boer War (and earlier wars and skirmishes), Baden-Powell wrote to Ernest's mother the letter reproduced on page 96 (the address is slightly incorrect). It perhaps tells us something about Baden-Powell's and others' inner wrestles with, on the one hand, the issues of loss, tragedy and sympathy, and on the other those connected with duty, self-sacrifice and the greater good.

In addition to local papers, both *The Times* and the *Church Times* carried brief details about Ernest's death and his career. Quite quickly, parishes Ernest would never have known, started to refer to the loss of Ernest. A tribute in *The Sign*, for example, was published in the September 1917 parish magazine of St. Bartholomew's Church, Horley. (Various other memorials and images are shown at the end of this chapter.)

Captain Roland Philipps's brother, Colwyn (also a captain), had been killed in 1915; Roland would join him on the other side in little more than a year's time. Other Scoutmasters and Commissioners of high repute had gone or were destined to go the same way, namely: Roland's close Scoutmaster friend Anthony Slingsby (a one time Headquarters manager), Dr. Lukis, founder of the Toynbee Hall Scout Troop, and South London Scoutmaster Maurice Gamon.

95

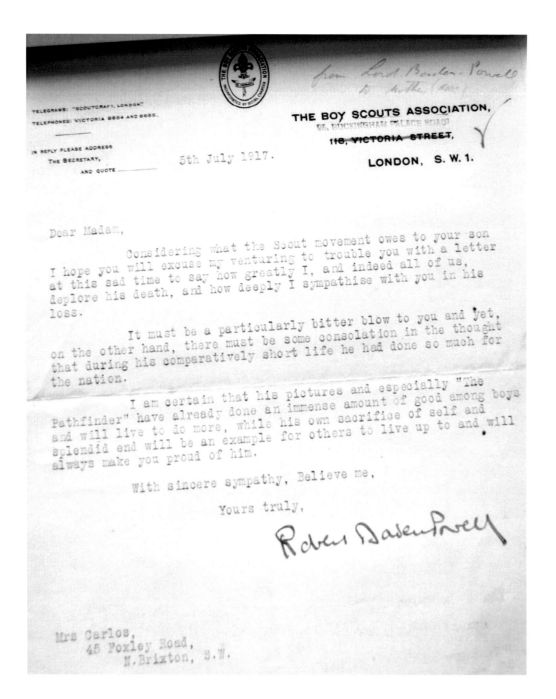

TELEGRAMS: "SCOUTCRAFT, LONDON"

TELEPHONES: VICTORIA 8654 AND 8655.

IN REPLY PLEASE ADDRESS
THE SECRETARY,
AND QUOTE

5th July 1917.

THE BOY SCOUTS ASSOCIATION,
25, BUCKINGHAM PALACE ROAD,
116, VICTORIA STREET,
LONDON, S. W. 1.

from Lord Baden-Powell
to Mother (me)

Dear Madam,

Considering what the Scout movement owes to your son I hope you will excuse my venturing to trouble you with a letter at this sad time to say how greatly I, and indeed all of us, deplore his death, and how deeply I sympathise with you in his loss.

It must be a particularly bitter blow to you and yet, on the other hand, there must be some consolation in the thought that during his comparatively short life he had done so much for the nation.

I am certain that his pictures and especially "The Pathfinder" have already done an immense amount of good among boys and will live to do more, while his own sacrifice of self and splendid end will be an example for others to live up to and will always make you proud of him.

With sincere sympathy, Believe me,

Yours truly,

Robert Baden Powell

Mrs Carlos,
45 Foxley Road,
N. Brixton, S.W.

Despite the tragic losses, and Scouting's founder describing the war as 'this reversion to primitive savagery' and 'scientific execution', he knew that there was no alternative. The war had to be won at any cost. Tim Jeal comments on Baden-Powell's outlook:

Yet even after Philipps, Lukis, Gamon and Slingsby had all been killed, Eric Walker [a personal friend and Headquarters Commissioner] *captured and Olave's* [his wife's] *brother gravely wounded, he felt no less sure that defeat could never be countenanced. He therefore urged his orphaned nephew, Donald to join the army quickly. The war, Baden-Powell told the boy, was 'the greatest event in our national history' and no man had the*

right to deny himself the chance of serving. Donald joined the Rifle Brigade and, although wounded, survived.

Yet another Scoutmaster (and fortunate survivor of the Great War) from the same mould as Ernest and Roland Philipps was one Sidney Marsh. If Ernest never actually came across Marsh in person - and Marsh's home and Troop were not far away, being just off the Walworth Road and close to the Elephant and Castle - he could not have failed to be aware of the tragic loss of life of eight of his Walworth Scouts. The Troop's cutter overturned in the Thames estuary while the boys were heading towards their summer camp at Leysdown. The drownings made national news in August 1912, and two years later a bronze memorial statue of a Boy Scout was erected on the grave of the interred boys at Nunhead Cemetery (one of the victims was named Percy Baden Powell Huxford). Coincidentally, the grave (shown below, minus the fine statue, which was stolen in the 1960s) is only across the pathway - now named Scouts Path - from the rather more hidden and overgrown Carlos and Buckler family graves.

Marsh, a former pupil of Dulwich College, ran his Scouts in conjunction with St. John's Church, Larcom Street (which is where Charlie Chaplin's parents were married). Although some of the boys may have been pupils at St. John's School, one, William Beckham, had just completed his first year at Wilson's Grammar School, where three of the Carlos boys had recently been pupils. Footballer David Beckham (who was actually a Scout at one time) is descended from the same family line as young William. Sadly, William Beckham lost his life in the tragedy, though two of his brothers also on the same camp survived.

Unreferenced tribute to Ernest found in the family archives: ... *The Summer Camp of Bishop's School, Salisbury, was for several years the gainer by his gifts of organization and resourcefulness. A man whose religion was part of his very moral fibre, quiet but always bright and cheerful, with an undercurrent of humour, unspoilt by success, tactful and ever ready to say the right thing at the right moment, devoted to a home where "service for others" had become a household word, beloved by all those who had come under the spell of a charming personality, he passed through life spending and being spent for others, and now that he has crowned his life's work by the final sacrifice his friends are poorer indeed for the loss, but richer for the example he has set...*

It will interest all who love S. Michael's children to know that a strong class of teachers are now preparing to take up work in S. Michael's Kindergarten. We are most grateful to Miss A. Brewer, for undertaking their training. Will parents please remember that this Kindergarten starts work on Sunday, September 2nd, and send all their children still of suitable age.

Notes and News.

A very successful meeting of the various **Men's Wards of our Guild**, was held on May 31st. It was unanimously decided as a temporary measure, to amalgamate the Wards of S. James, S. Joseph, Reverence, Perseverance, and Holy Name (senior). It was also unanimously decided to hold a joint meeting once a month on the last Monday, at 8.30 p.m., beginning September 24th. The Meetings are to consist of the Guild Office and address in Church, followed by a short social gathering in the Elliott Road School

The very deepest sympathy of one and all of us will be felt for **Mr. and Mrs. Carlos and their family** in the death of their son Ernest, who has recently been killed in action. It is to Ernest Carlos we owe the beautiful portrait of Canon Brooke that we all value so highly, and he had almost finished another portrait of our late Vicar, Canon Deedes. He was, however, compelled to leave for the Front before the finishing touches had been given. We thank God for his life, and the noble death, that with so many others, he has died. May he rest in peace, and may light perpetual shine upon him.

We should like to remind our readers that, as was stated in a note at the end of the last monthly music paper, the **New Supplement to Hymns, Ancient and Modern** will come into use in July. Of course, these new hymns will be introduced gradually, but we hope that all our parishioners will furnish themselves with a copy, which, at various prices, can be obtained at Mr. Starr's book-shop. Words only can be had at 3d. or 5d., large type 10d; and with tunes, at 1/3 and 2/3.

We are issuing copies of the **Church Journal** in **two forms**. For copies of the CHURCH JOURNAL in **grey cover** the charge will be **one penny**, and bound up with "The Sign" in **red cover** the charge will be **three halfpence**.

Baptisms.

April 25th—Gladys Alma Hoare. May 3rd—Edward Daniels. George Henry Pettifor.

May 6th—Ellen Rose Holding. May 20th—John Hickey. May 26th—Joan May Bullard. Birdie Ivy Elded. Catherine Trinder. May 27th—Albert James Webber. Leslie Charles Cockerill. Graham Richard Cockerill. Phyllis May Tibbles. May 30th—Frederick William Woods. Gertrude Woods. June 1st—Doris Margaret Rogers. June 3rd—John Thomas Dillon. June 9th—Jack Bundock Brown. June 10th—Bessie Victoria Farrah. Louis Percy Farrah. June 12th—Charles William Blackburn. Rose Pratt. Violet May Crewes. June 17th—Irene Mary Gregory. June 18th—Ernest Barton. Joseph Connell Worrom.

Marriages.

May 24th—Thomas Needham Stairs and Edith Ellen Sanders. May 27th—Charles Henry Gurr and Martha Jane Bowler. June 11th—Arthur Alfred Webster and Alberta Ivy Smith. June 17th—William Fermin and Eliza Jane Holman.

Deaths.

Allen Edwards, *Priest.*
Edgar Charles Houlston, *Priest.*
Thomas Jee. Thomas Henry Coffield. William Hunt. Alfred Riches. Cyril Percival Baker. Ernest Carlos. Walter Alfred Wilford Redoubt. Frances Wheeler.

Church Collections.

From the 20th May to the 24th June, 1917, inclusive.

	£	s.	d.
Church Expenses	35	2	3
Parish Expenses	7	14	3
Church Insurance Fund	3	16	9
Sunday School Fund	0	19	0
Guild Fund	0	5	0
Guild of All Souls	0	7	8
Ward of S. Mary	0	6	7
Ward of Good Shepherd	0	2	10
S.P.G.	14	18	9
U.M.C.A.	14	18	9
Assistant Clergy Fund	10	12	5
Altar Fund	3	5	4
Metropolitan Hospital Fund	33	0	9
	£125	10	4

The Church Collections for July will be as follows:—

Sunday, 1st.—S. John the Divine, Quesnel.
 „ 8th.—Church Expenses.
 „ 15th.— do.
 „ 22nd.— do.
 „ 29th.— do.

✝

Ernest Stafford Carlos.
Killed in action, June 14-15th, 1917.

The news of Mr. Carlos's death will come as a blow to us. Mr. Carlos was a distinguished artist and his Boy Scout pictures are well known. He was always ready to use his talents in any work. During the last seven or eight years he has helped us in the New Church Road Sunday School, in the Band of Hope, on the Care Committee, with the Scouts, and, above all, we think of him in connection with the Sales and the way he put himself unreservedly at our service for them. Many of us will think of him as one of the humblest men we have ever known. It was his complete self-forgetfulness that drew him to those with whom he worked.

Mr. Latham writes: "He was one of the most unadvertisingly unselfish men I ever met. His way of rendering brilliant service, without the slightest consciousness that he was doing any-thing out of the way, was rare and inspiring. Requiescat. They will be a goodly company that meet on the other side."

Alfred Budd
Robert Budd
William Budd
Alfred H. Burrell
Ernest Henry Burrows
William A. Bushby

William Campion
Ernest Stafford Carlos
William Carlton
Henry Thomas Carmoody

Above right: Ernest's name appears on this parchment (there are quite a few names on several parchment lists) that was once on a First World War memorial wall in the first St. George's Church, Camberwell. The parchments and glass cases are due to be restored.

Above: Nunhead Cemetery, which was established in 1840 by the London Cemetery Company, who had opened Highgate Cemetery in the preceding year. At 52 acres, Nunhead was the largest of London's seven commercial cemeteries and was at that time largely surrounded by fields and farms. Whilst Ernest's parents' and maternal grandparents' graves have been located, that of his paternal grandfather - Edward John - has yet to be found (neglect and vandalism in earlier decades may make this impossible).

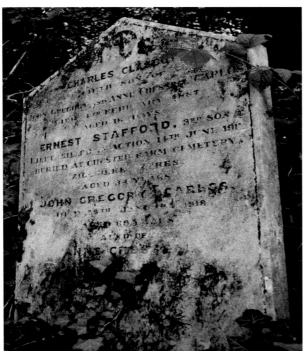

Not easy to read, and a poignant sight, the grave reminds us of little Charles Carlos, who lasted just sixteen days. Ernest's name has been added (but it says where he is buried); his father's death followed about a year and a half later. Mother Anne was interred in February 1934. The Buckler family grave is the next one along.

Bottom: This memorial can be seen on the left-hand side just as one walks into the public entrance to the galleries at the Royal Academy, Piccadilly.

TO · THE · MEMORY · OF
THOSE · STUDENTS · OF · THE · ROYAL
ACADEMY · WHO · FELL · IN · THE
GREAT · WAR · 1914–1919 · THIS
MONUMENT · IS · ERECTED · BY
THE · MEMBERS · AND · STUDENTS

BAIRD · NINA · I	DAVIES · W · E	SKINNER · H · E · C
BARRY · F · R	GORDON · D · J	SMITH · C · L
BELLAMY · O	HAYWARD · C · G	SMITH · V · N
BENSON · H · C	HILLYER · W · H	SMITH · W · H
BINNING · A	HOLDER · C · V	STREATFEILD · J · P · S
BUNBURY · H · St P	LEWIS · TOBIAS	SWINTON · J · G
CALDERON · F · E	LITTLE · N · J · R	SYMONS · J · A
CARLOS · E · S	MILNE · DAVID	TURNER · T · E
CLARK · W · L	PAPWORTH · A · W	VINEY · C · H
CORBETT · A · E	PARAMORE · C · G	WALLIS · C · F
CRISP · F · E · F	SAVAGE · W · B	WEBB · PHILIP L
CRUICKSHANK · D · E	ORCHARDSON · C · M · Q	

EMILE · MADELINE · SCULPT
H · TYSON · SMITH · FECIT

TRENWITH · WILLS · INV · T

FAMILY LIFE AFTER ERNEST'S DEATH

I hope to get back to my so called slum work and who knows someday we may be working in the same parish.

<div align="right">Last sentence in Ernest's letter to his brother Jack, 1916</div>

A compass was all that was found on Ernest's body after he was killed. The line above indicates where his own moral compass pointed. But it was not to be. Around a year and a half later, the devastated family would lose a father and husband - John Gregory - in January 1919 (the same month his own father had died). Ernest's mother, like so many of her generation, seems to have been very stoical. In her brief pamphlet on the history of the Childer Chaine (which she had founded), although family members were closely associated with it, she only mentions in passing the loss of her husband. The loss of her son is referenced thus:

1917. The "At Home" in January was marked by a "Procession of Children" attired in costumes from Ancient British times to the twentieth century, Father Time leading and suitably addressing the audience. Through the dark, terrible times that followed with their anxiety and load of heart-breaking losses "the cry of the children" was still heard, and we continued the labour of love our dear ones had laid down, some of us gaining comfort in that thought.

With a reduced family size and two of the brothers living independently now, the Carlos family moved out to Kent. The move to their new home - known as 'The Priory' - at 2 Homesdale Road, Bromley, may have been connected with Ted's appointment as organist at St. Mark's Church, Bromley in 1919.

Ted had had various South London appointments before and during the war, for example at St. Paul's, Walworth in 1908, and at St. James's, Myatts Park in 1915. At this time he also played the organ at King's College Hospital (which had only recently moved to Camberwell from central London). Whilst at St. Paul's or elsewhere, he may well have come across the Revd. James Baden Powell, who was at one time a well-known figure in South London and friend of St. John's Canon Brooke.

Above: A reminder of Lambeth. It is one of Ernest's portraits of Canon Brooke, here on display at St. John the Divine's. A secondary school bearing his name still exists locally.

The Revd. James Baden Powell was a cousin of the future Lord Baden-Powell and often officiated at Baden-Powell family ceremonies (like Scouting's founder, he was a member of the Mercers' Company, an ancient livery company in the City). Indeed, the Revd. performed the officiating duties at the christening of Lord and Lady Baden-Powell's only son Peter.

The Carlos family, similarly, did not cut themselves off from Scouting. Just down the road from their home, in Glanville Road could be found the 3rd Bromley Scouts, founded in 1909 (and still flourishing today). For the Group and the District Ted was registered as a badge examiner - unsurprisingly, for the Musician's badge. The 3rd Bromley's records also show that Ted arranged a piece of music for the opening of their new Scout hut in 1930. Interestingly, brother George, of whom we know very little, is listed as being a bass player in the orchestra.

In addition to Ted being organist at St. Mark's, brothers Bob and George sang in the choir. Alan Hills recalled something of the brothers when writing about his schooldays for the publication *Bromleage* (of March 1997):

One day the choirmaster and organist from St. Mark's, Mr. Edward Carlos came to select choirboys and as I always liked singing I found myself picked. Edward, referred to out of his hearing as Ted, had a twin brother Bob or Robert who sang in the men's section.

The twins were rather Spanish featured. Ted had a rather bad stammer which I found, rather unkindly, I could increase by looking him straight in the eye.

They lived in a large house in Homesdale Road, Bromley Common where those unsightly concrete offices now stand [which were in turn demolished]. *Their house was named 'Boscobel'* [actually a house near Bromley they lived in after their mother's death] *as I later learned one of their ancestors had helped Charles II...*

Their big old car, an Austin, I think, had a coat of arms on its door, which several of us used to pile in for trips to Otford church to sing at their Harvest Festival, and were afterwards regaled with cakes and drinks by the ladies of the village.

As can be seen, the Carlos household, although nearer 'the sticks', still remained very active. Anne, whilst also a keen member of St. Mark's, continued organising Childer Chaine activities. Her son Arthur Sidney, by now working as a research scientist and living with his own family in Hayes Lane, Beckenham, became a member of Hayes parish council. Whilst he and older brother, the Revd. John Carlos, would have various Scout appointments, Arthur still kept in touch with Ernest's Camberwell Troop. With his mother now in her eighties, he supported the Childer Chaine too. A report in *The Times* records the Prince of Wales visiting Clapham's Belgrave Hospital for Children in May 1932. It also mentions Arthur: ... *In another ward he had a talk with Mr. Arthur Carlos, secretary of the Childer Chaine, a children's organization which collects farthings for the hospital. Over 1,500,000 farthings have been obtained by the children in the last 15 years, and the Prince met 14 of the young members of the Chaine in the ward.*

Anne Carlos ended her days two years later at Homesdale Road, dying after a short illness in February 1934. A service was held at St. Mark's and her body was laid to rest with her husband's at Nunhead Cemetery.

As touched on earlier, Nina and the unmarried Carlos men moved to another house situated in Oakfield Lane, Keston (and named 'Boscobel'). However, by the start of the Second World War, with Ted taking up an appointment as organist at the Priory Church, Leominster, they all left their Kentish surroundings. Ted would remain in post for some twenty-three years before retiring. He and twin Bob died in late 1970, within a fortnight of each other.

Above: The Carlos family home in Bromley, - 'The Priory', 2 Homesdale Road - near Bromley Common (when writing this, I noticed that coincidentally the phone number for the address was Ravensbourne 2013). It was here that Cubs and Scouts visited when being tested for the Musician's badge. It was also a local Bromley printer who ran off further colour copy prints of *The Pathfinder*, which continued to be sold in Scout Shops and distributed around the world.

Right: Anne Chessell Carlos. Even in ripe old age, her ever practical side can be seen in the fact that she is still wearing a chatelaine: a useful device worn at the belt/waist and holding clips for such things as scissors and keys.

Below: A contrast of life and death - certificates kept in the family archives.

E S CARLOS: ASSESSED BY ART HISTORIAN PAUL LEWIS

Ernest Stafford Carlos worked throughout an interesting, indeed turbulent, period in British art history. This saw the impact on the later Victorian and Edwardian world of Realism, Symbolism, Impressionism and Post-Impressionism.

The Royal Academy was no longer the only arena in which to view modern art, though even that institution hosted differing audiences viewing a variety of genres - from the staple of portraiture, to the recreations of Greece and Rome through landscape and still-life. But there was another emerging strand of what we might now call Social Realism.

While Carlos seems to have been largely untouched by the more radical Continental movements, he would certainly have been aware of paintings and reproductions of works by Luke Fildes, Stanhope Forbes, Frank Holl and Hubert Herkomer. Stanhope Forbes, famous for his scenes of life and labour in Cornwall, was among the impressive cast of tutors at the Lambeth School of Art, attended by Carlos. Far removed from the classical scenes of Edward Poynter, Lord Leighton and Alma-Tadema, the paintings of these artists depicted working people and addressed social concerns of the day.

Carlos could not have been unaware of the powerful and unsentimental images of Holl, Fildes, Forbes and others. But he was no Bohemian and did not go to the Slade, from which emerged such dynamic and varied talents as those of Spencer Gore, Augustus and Gwen John, Wyndham Lewis and, a little later, Paul Nash, C W R Nevinson and Stanley Spencer. These latter depicted the First World War in ways very different from Carlos, who remained a private and anecdotal recorder of scenes in camp, an unofficial war artist.

Carlos was a conservative in technique but relatively radical in his chosen subject matter. As we see in photographs of his studios (page 63) he relied, like many of his contemporaries, on the production of portraits and landscapes for his living. He was also commissioned to make copies. On page 70 we see him copying Hoppner's *Lady Charlotte Campbell as Aurora*, which still hangs in the Tapestry Room of Inverary Castle. Copying had been a lucrative business both for professional copyists and artists themselves, at least since the seventeenth century. While making multiple copies was a chore it had some benefits. As an educational exercise copying was part of an older academic regime. It required students to give close reading to paintings and their making. Carlos was gaining insight into the variety of brushwork and glazes employed by earlier artists.

But he chose to do the Scout paintings. They focussed his social concerns. It is tempting to speculate on what his career might have been had it not been cut short. He was already a mature artist in 1917. Had he lived he would have been working in a world of changing patronage and media. The fact that many of his older mentors survived him and continued to find audiences suggests that he could have been among their ranks. But his social concerns were a moral force and might have found expression in the documentary mode that was emerging in the Europe of the 1920s.

As we have it, Carlos's work sits between the categories of High Art and Popular Culture and he might even have found, as did Herkomer, possibilities in the cinema. So much more than just another journeyman artist, Carlos was also more than the official artist of the Scout movement - but to be remembered as that is no mean achievement.

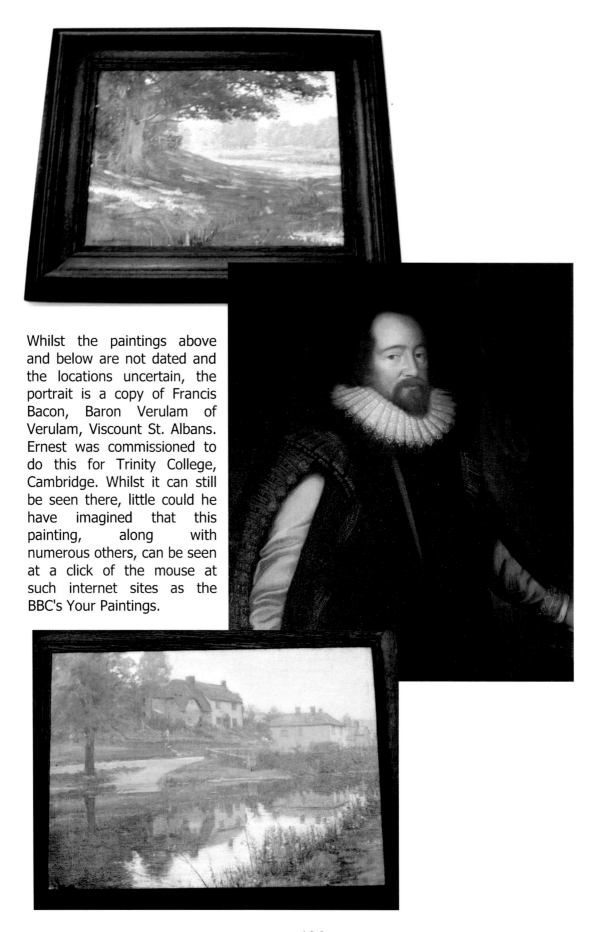

Whilst the paintings above and below are not dated and the locations uncertain, the portrait is a copy of Francis Bacon, Baron Verulam of Verulam, Viscount St. Albans. Ernest was commissioned to do this for Trinity College, Cambridge. Whilst it can still be seen there, little could he have imagined that this painting, along with numerous others, can be seen at a click of the mouse at such internet sites as the BBC's Your Paintings.

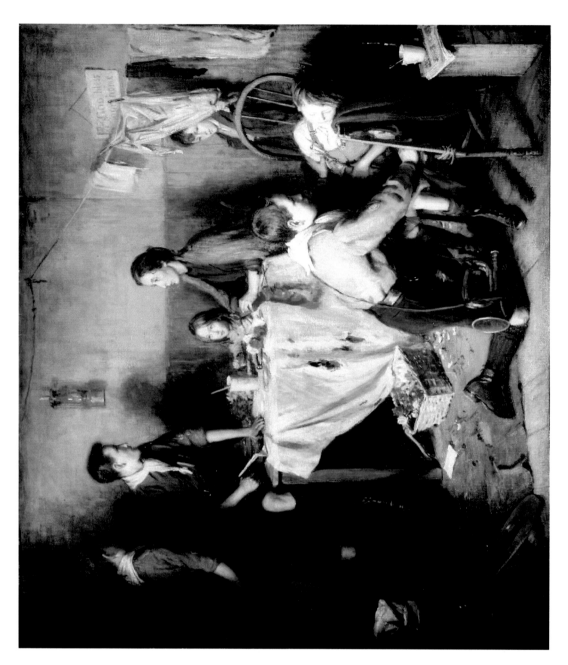

Ernest's *Good service work in a London slum*, painted 1913. The Patrol Leader at the table is said to be Alf Emins. The Scouts sold the paper flowers made by the family to help put food on the table. The label (right), showing location of an exhibition and price, gives an indication of how the artist's reputation was expanding.

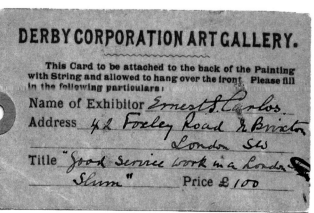

107

A PROLIFERATION OF PLAQUES IN SOUTH LONDON...

SOUTH LONDON PLAQUES AND AN AFTERTHOUGHT

The South London plaques shown opposite are only a few of many. Famous former residents in South London have been as diverse as William Blake, who lived in Hercules Road, SE1 for ten years and music hall comedian Dan Leno, who, as his blue plaque tells us, once lived at 56 Akerman Road, SW9 (a few roads away from Foxley Road).

In addition to artist Van Gogh, South London's hall of fame also includes: John Ruskin, Robert Browning and, in more recent decades, Bermondsey boy Tommy Steele, Michael Caine and Peckham lad, footballer Rio Ferdinand. Caine (originally named Maurice Micklewhite) was brought up in the Elephant and Castle area. Ruskin lived in what were then more rustic surroundings of Camberwell and Herne Hill, at 163 Denmark Hill (composer Felix Mendelssohn stayed at 168 Denmark Hill. He here composed his *Spring Song*, which was originally named *Camberwell Green*). Composer Gustav Holst taught at James Allen Girls' School, Dulwich, he later became musical director at Morley College.

This book started with an image of artist David Cox's blue plaque in Foxley Road. Cox, the son of a Birmingham blacksmith, first lived at 16 Bridge Row, Kennington, but came to 9 Foxley Road in 1827. Strangely, he would be buried on 14th June 1859 (14th June being the day Ernest was killed). His artist son, David Cox junior, also lived at 9 Foxley Road, though when he married he settled in Cowley Terrace. Ernest's grandparents, when they married, first settled in Cowley Road. Sadly, the wife of David Cox junior committed suicide on 14th June 1854. By this time David Cox senior, a much travelled man, was a

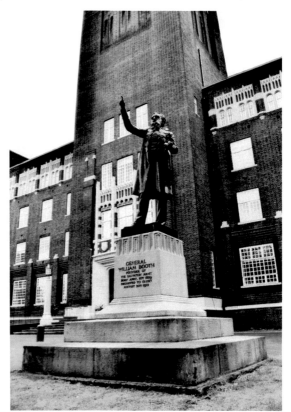

William Booth memorial at the Salvation Army's training college, Denmark Hill.

regular visitor to the picturesque Welsh village of Betws-y-Coed. Something of a local celebrity, he here painted the sign for the Royal Oak Hotel. It depicted Charles II hiding in an oak tree (and can still be seen in the Hotel today). The Hotel would also be the base for Dulwich Preparatory School for the duration of the Second World War.

In the 1980s an approach was made to the Greater London Council for a plaque to be put up for Ernest Carlos. I am uncertain why, but nothing came from the approach made. Perhaps it is time a fresh approach was made to the appropriate authority.

Plaques on page 108 (left to right)
1. Charlie Chaplin, Methley Street, SE11.
2. Van Gogh, 87 Hackford Road, SW9.
3. Charles Babbage, Walworth Road, SE17.
4. Robert Browning, Southampton Way, SE5.
5. William Henry Pratt (better known as Boris Karloff), Forest Hill Road, SE22.
6. William Bligh, Lambeth Road, SE1.

ADDITIONAL NOTES AND IMAGES

CONTENTS:

MORE ON *THE PATHFINDER* page 111

SALES AND EXHIBITIONS page 115

APPROXIMATE VALUATIONS page 116

CARLOS PAINTINGS OWNED BY (OR IN THE
CARE OF) THE SCOUT ASSOCIATION page 116

LIST OF ERNEST'S WAR TIME SKETCHES page 117

NOTES ON ERNEST'S SCOUT TROOP page 118

FURTHER NOTES ON THE REVD. E S
CARLOS page 119

MORE ON ERNEST'S SIBLINGS page 121

MORE ON THE BUCKLERS page 122

ACKNOWLEDGEMENTS AND
PICTURE CREDITS pages 127 -
 128

MORE ON *THE PATHFINDER*

What was Ernest trying to convey in *The Pathfinder*? It can mean different things to different people. The chink of light around the door signposted what Scouting represented: the great outdoors, adventure, being outside and active, living a healthy life, the world is your oyster… On the other hand, boys were vulnerable, wrong paths could be taken; they needed a guiding hand. Life was a journey, but not one that had to be taken alone. For a Boy Scout, life was about service and duty - all done in God's name.

The enlarged image below is from the Philipps' window shown on the front cover; its designer has chosen to add appropriate biblical text.

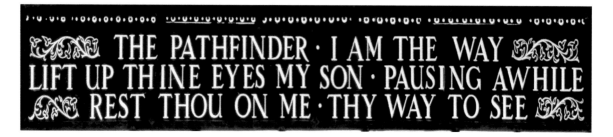

'Pathfinder' was also a term Ernest would have been familiar with, early Victorian American author Fenimore Cooper had written adventure stories, some about woodcraft and Red Indians, a republished one (*c.* 1900) was titled *The Pathfinder*. One of the latest proficiency badges in the Scouts was the Pathfinder badge (at one time it was needed for a Scout to get the top award: the King's Scout badge). A Scout-class cruiser launched in 1905 was called HMS *Pathfinder*. In 1912 Lieutenant Commander Stuart Garnett, Scoutmaster of an up and coming London Sea Scout Troop - the 1st Ratcliff Sea Scouts - had named one of his Troop's gigs *Pathfinder*. Lastly, after the Great War the magazine *Bibby's Annual* published an article titled 'Pathfinders', which seemed to encourage others to be pathfinders; among its highlighted heroes were such people as Brunel, Livingstone, Bacon, Newton and Wren.

In some of his paintings (including *The Pathfinder*), for some reason Ernest had a penchant for adding intriguing scraps of paper or opened books on the floor.

Highly spurious, within the Scout movement it was once passed around that when the artist was painting *The Pathfinder*, he (or else Baden-Powell himself) had wanted Scouting's founder to be the guiding figure behind the Boy Scout. This idea was altered because it was feared that some people in the movement (and others outside) would find it too sacrilegious to have Baden-Powell as 'the hand of God'.

It is certainly true that to many boys in the pre-First World War era, Scouting was like a new religion. Whilst many clergy recognised Scouting as a force for good - even a way of getting or keeping boys in church - others feared it would take over a boy's life and lead him away from the Church. Thus, in some cases there were tussles, with vicars reminding boys and leaders about their more important obligations to the Church; they tried to control how Scouting was done, for example discouraging Scouting on a Sunday. For the boys,

Scouting was the equivalent of today's football mania. Instead of collecting football scarves, kit and badges, Scouts hankered after their very own hat, knife, water bottle and stave. The person a good many of them idolised was their Scoutmaster; the God-like 'player' they all idolised was 'B-P'.

Below: A spanner in the works?

News from Canada

THE following is an extract from "The Yeoman" printed in May this year at Ontario, Canada:
 "Most of us at one time or another have noticed and admired that beautiful and inspiring picture, Ernest Carlos's masterpiece, "The Pathfinder." Well the boy who posed for the central picture is now a member of the Melita crew, the same Percy Cole who joined us the other night. He is now a man of about 35 and a real Rover Scout, with a wealth of Scout tradition in his make-up. He was kind enough to present the Crew with a beautiful coloured reproduction of the picture in question. We are proud to announce this unique feature of our Unit. May we get more like Percy.
 (*Signed*) H. P. MUSSON, R.S.L."

three

The report above appeared in a regularly published magazine of a north London Scout Troop in the summer of 1934. Based in the Hornsey area, the magazine was titled *The Ferme Park Scout*. Whilst it is true that Percy Greaves posed for some of Ernest's paintings, the evidence above (not the only alternative view I have come across) casts doubt that Percy sat for *The Pathfinder*. Percy Cole ('Percy' adding to the confusion) was a local Boy Scout (I am not sure if he was a member of St. John the Divine) before the Great War, and his father was a South London Scoutmaster. It is quite likely that he sat for Ernest, and quite likely that he emigrated to Canada when a little older. On the other hand, did Percy Greaves later change his name? Unlikely. Another possibility, with Ernest having sketches of Percy Greaves in his sketch book and artist's mind's eye, it may be that either each Percy posed for each version of *The Pathfinder* (there were at least two full versions done) or else the boy in *The Pathfinder* may well be a combination of Percys!

NOTES ON THE STAINED GLASS WINDOWS

Stained glass windows using *The Pathfinder* image were sometimes dedicated to Boy Scouts who had fallen in one of the World Wars or who died through illness or injury. One in Middleton, Manchester, is a case in point. Recently restored, it was originally unveiled in Wade Street Scouts and Guides headquarters in November 1924, in memory of the 3rd Middleton Boy Scouts who fell in the Great War. Not necessarily definitive, the following is a list of all known *Pathfinder* stained glass windows in the UK (most of which originate from the 1920s and 1930s): St. Seriol's, Holyhead, Anglesey; St. John's, Belfast; St. Mary's, Roch, Pembrokeshire; St. Mary in the Lace, Nottingham; St. Saviour's, Shanklin, Isle of

Wight; St. Gabriel's, Middleton Junction, Manchester; Erdington Six Ways Baptist Church, Birmingham; Holy Cross, Hornchurch, Essex; St. Nicholas College, Chislehurst, Kent. The last mentioned is now Bullers School. The window was later removed to Addington Palace (the window is not a true Pathfinder image, it depicts a kneeling Scout with two choirboys); from Addington it was removed to Dorking and from there to its current home at the Royal School of Church Music, Salisbury. Lastly, *The Pathfinder* has travelled overseas. To this day it can be seen in the church of St. George's and St. Jude's, New Brunswick, Canada. The window was erected there in 1937, in memory of a long-serving Scoutmaster (it is depicted on page 126).

CORONATION STREET

The first ever episode of *Coronation Street* was broadcast live on 9th December 1960. A sepia print of *The Pathfinder* belonged to fictional 'uncle' Albert, also known as Albert Tatlock (acted by Jack Howarth). He left it to his nephew Ken Barlow (played by William Roache). Look carefully and it can still be seen on an interior wall in Ken Barlow's home.

Right: Food for thought. This is the cropped and enlarged image from page 82 (taken from a black and white photo found in a Carlos photo album). Can you spot any minor differences between this and any of the other *Pathfinder* images?

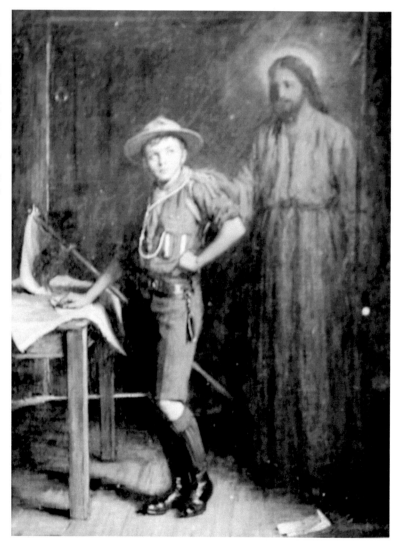

Below: Confusing! The sitter is now a left-hander. I think it is merely because the photo has been produced from the original glass plate and has been reversed during the process. However, the detail in Christ's hands and feet is very clear, and notice how his hand doesn't actually touch the Scout's shoulder. Either this painting was reworked and became one of the two existing *Pathfinders* or was there a third *Pathfinder*?

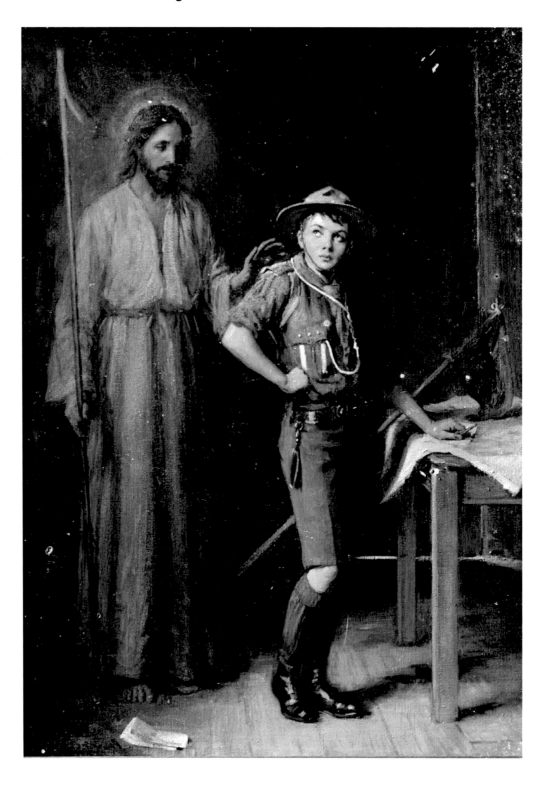

SALES

(TAKEN FROM ARTINFO ART SALES INDEX)

Young boys on Cliffside, mid summer, 12" x 16". Sold at Christie's in December 1990 for $1,940 USD (price quoted in US dollars).

Thirst for Knowledge, 21" x 17". Sold at Christie's in December 1990 for $5,626 USD.

Guarding the Coast, 50" x 55". Sold at Butterfields, San Francisco in March 1991 for $900 USD.

Boy Scout Playing Bugle, 14" x 10". Sold at Sotheby's in January 1993 for $900 USD.

Two Boy Scouts in Field, 9" x 13". Sold at Bonhams in June 1993 for $608 USD.

Boy Scout and Leader, 39" x 50". Sold at Grogan and Company in October 1995 for $1,500 USD.

Coast Watching, 50" x 55". Sold at Phillips in December 1996 for $2,324 USD.

Time for Thought, signed oil on canvas, unframed, 36" x 24". Sold at Christie's in July 1999 for $ 1,560 USD (also reported as £1,150).

Young Scout's Duty, 18" x 12". Sold in March 2005 at Doyle, New York for $2,200 USD.

Portrait of a Lady, 16" x 12". Sold in February 2006 at Thomas Roddick and Medcalfe, Carlisle for $592 USD.

OTHER EXHIBITIONS AND SALES

There is not room to list all of Ernest's paintings, a good deal are now in private hands (numerous Scout related ones but also others). When away, he liked to produce his own postcards to send home. A scrap book of these, and also a sketch book, are now in private hands.

1908 Ernest actually had an exhibition of his paintings at Church House, Salisbury.

1973 - The Scout Association (at Gilwell Park, Chingford) exhibited various Carlos paintings on loan from Revd. Francis Carlos. *The Pathfinder* was exhibited here and also in 1974 at Shrewsbury Art Gallery.

1982 - Sales at Christies: 26 pictures and paintings from the Carlos studio.

APPROXIMATE VALUATIONS OF ERNEST'S
SCOUT PAINTINGS

When *The Pathfinder* was sold it cost its first purchaser £50.00, interestingly although it has always been the Scout movement's most popular painting (or at least most reproduced), Ernest's earlier *If I were a boy again* sold for more (£65.00). Valuations provided to the author by the Scout Association in 2012 still show that *The Pathfinder* falls below other Scout paintings owned by or in the care of the Scout Association (though the size of canvas presumably plays a part in this, along with framing and whether or not a picture is signed).

Raw Material £11,000
Good service work in a London slum £11,000
The Pathfinder £8,000
A Ripping Yarn £6,000
If I were a boy again £9,000 (originally bought by the Hon. Roland Philipps in 1913 for £65.00).
Time for Thought £6,500

**Time for Thought* was sold at Christie's in 1999 for £1,150. Christie's also valued the paintings below in 1994 (for 'fair market price'):
Be Prepared, £3,300
Raw Material, £6,600
Good service work in a London slum, £6,600

CARLOS PAINTINGS OWNED BY (OR IN THE CARE OF)
THE SCOUT ASSOCIATION

The Pathfinder (framed), *c.* 1913.
Raw Material (framed), *c.* October 1915.
A Ripping Yarn (framed), presented to the Scout Association by Bill Hall, Jersey, 1982.
**Good service work in a London slum* (framed), *c.* 21st June 1913.
His Country's Flag, *c.* April 1914.
If I were a boy again (framed), 1911.
Headquarters (framed; renamed *Be Prepared*, exhibited at the Royal Academy 1912).
Day Dreams (framed), presented by Bill Hall, 1982.
Coast Watching (framed), 1915. Shows two Sea Scouts on the cliffs of Dover watching for u-boats. Presented by Bill Hall, 1982.
Time for Thought (framed), not dated.

*The sitters for this painting are known because Ernest numbered them and wrote their names and addresses on the sketch he did for the painting. Their names are: F J Goodwin, A G Pruden, J R Dear. He also added the unnumbered names: D Jerrom, A E Emins and I Hart.

CARLOS PAINTINGS THAT WERE LISTED IN THE 'GREAT WAR' EXHIBITION AND CATALOGUE OF DAVID COHEN FINE ART, LONDON, NOVEMBER 1991

Wind Up - near Lievan, signed and dated 21 April 1917. Watercolour, 5½" x 8¾".

A French farm girl at Abeele, near Poperinghe, 1917. Watercolour, 5" x 7".

Soldiers listening to a gramophone at Abeele, 1917. Watercolour, 5" x 7".

Officers relaxing on a sunny day at Poperinghe, 1917. Watercolour, 5" x 7".

Three officers playing cards at Poperinghe, 1917. Watercolour, 5" x 7".

Captain Rice and 2nd Lt. Lilley playing cards at Poperinghe, 1917. Signed watercolour, 5" x 7".

Cleaning equipment behind the lines, 1917. Signed watercolour, 5" x 7".

A 'bivvy' home-made by one of the men to sleep two, dated 10 June 1917. Signed watercolour, 4¼" x 7¾".

Note: A few Carlos war sketches and paintings (including the one below) are now kept by the National Army Museum.

OTHER KNOWN PAINTINGS BY ERNEST

1. Scouts by a bell tent. 2. *The Thinker*. 3. *The Cowshed*. 4. Scout. 5. Playing Draughts. 6. *War Service*. 7. *Studying the Chart*. 8. *Refreshments*. 9. Pitching a bell tent. 10. Sea Scout by a bell tent.

NOTES ON ERNEST'S SCOUT TROOP

In October 1913 Mr. Stock started the Scouts as the 105th South London (and/or Trinity Troop) as part of the St. George's missionary activities.

He joined the Coldstream Guards in 1914. Christopher Leeke ran the Troop for a while, and when he joined the army the Troop was carried on by its Patrol Leaders. But it finally petered out about 1920. Soon after that the Ernest Carlos Troop, the old 107th South London, moved from its early home in Peckham and became the St. George's Troop. Although Ernest's brother, Jack (the Revd. John Buckler) had helped to run the Troop, by the end of the war he was working in East London. In the early twenties, however, brother Sydney Carlos was registered at Scout Headquarters as being one of the assistant Scoutmasters with the Troop.

As Ernest's brothers were former pupils at Wilson's School, Peckham, one wonders if some or all of his Scouts were not from that school (perhaps done unofficially as the school ran its own Officer Training Corps).

Although not necessarily completely accurate, information about the Troop was published in a booklet celebrating 150 years (1824 - 1974) of the St. George's Mission:

In December 1914, a few schoolboys were selected to form the basis of a Scout Troop, under Mr. Ernest Carlos, the Royal Academician, who became well-known for his paintings of Scout subjects. The Troop made an excellent start, and is still going from strength to strength. After six months the Scout band made its first public appearance when it met the children returning from their Sunday School treat, and marched at the head of the procession from Peckham Rye Station back to the church. They held their first ten-day camp at Kempslade Farm, Dorking, in 1915.

D H Allport was a leading Scout Commissioner in Camberwell and south-east London. He was a Wilsonian and remembered (slightly) the Carlos boys. He wrote to the Scout Association archivist in 1943:

Somewhere about 1913 he [Ernest] *took up Scouting in Camberwell and ran a Troop which met in a hall built in the garden of the old United Girls' Schools Settlement in Peckham Road.*

It was stated in one source that Ernest kept a log book of his Troop's activities, but this has never been found. Later records and photos of Ernest's Troop are still in the keeping of the Scout Group, which continues Scouting at St. George's as the 21st Camberwell (Trinity) Scout Group.

FURTHER NOTES ON THE
REVD. ERNEST STAFFORD CARLOS

Although from an academic background, Ernest's uncle was known to say that he could make almost anyone understand mathematics. Whilst headmaster at Exeter Grammar School, the future Bishop of Liverpool was one of his pupils. His interest in India even led him to briskly enquire about teaching there in 1890. Soon after his mother died (who was living with him when he was headmaster at Exeter School), he wrote to the Secretary for the Government of India, Education Department, about the conditions of appointments in the Education Service of the Government of India. For whatever reason, he changed his plans and took up the post as Rector of Cheadle, Staffordshire. He worked tirelessly here among the poor until his death in February 1927 (a long run, having been in post at Cheadle for thirty-six years). Until much more recent times, his old parish had a 'Carlos Centre' named in his honour. Lastly, in addition to a book on India (see preface below) he was also author/translator of: The sidereel messenger of Galileo Galilei: and a part of the preface to Kepler's Dioptrics containing the original account of Galileo's astronomical discoveries - a translation with introduction and notes by ESC (published in 1880).

PREFACE.

THIS *Short History of British India* is intended to give a complete outline of the circumstances which have produced the present political and social condition of India. The details are to be found in the books on which it is based.

Such an account of India may prove of service as a School-book by supplying information, which seems a proper part of every boy's education in these days, when so many are taught to look forward to an honourable career in some of the various Civil and Military Services of India, or in the new field of Indian Plantations.

I am indebted to 'old Indian' friends for the correction of those chapters which relate to the physical geography of the country and the condition of native life under British rule.

E. S. C.

The Revd. Ernest Stafford Carlos (Ernest's uncle and older brother of his father) outlived his brother and two sisters. The first sister was Mary Ann Edith (b. 2nd April 1846, d. 20th November 1918). She married Charles William Sandford Corser, who gained a Master of Arts at Christchurch, Oxford in 1882.

The other sister was Eliza Mary (b. 21st February 1844, d. June 1887). She remained unmarried and lived with her Reverend brother at the Exeter Grammar School until her death.

It can be presumed that artist Ernest got his middle name Stafford from his uncle, unless it was to revive the family's earliest known times when they hailed from Brewood, Staffordshire in the seventeenth century. On the other hand, the Revd. Ernest Stafford Carlos (if not Ernest the artist) may have been named in honour of Lady Stafford. She was a female architect John Chessell Buckler worked closely with when redesigning parts of Costessey Park, a Norfolk estate (mostly demolished in the 1920s). Owned by the Catholic Jerningham family, the sixteenth century home was enlarged and embellished from 1826 under the watchful eye of Buckler, who supported the amateur Lady Stafford and her family. Together they produced a series of watercolours on their designs and rebuilding.

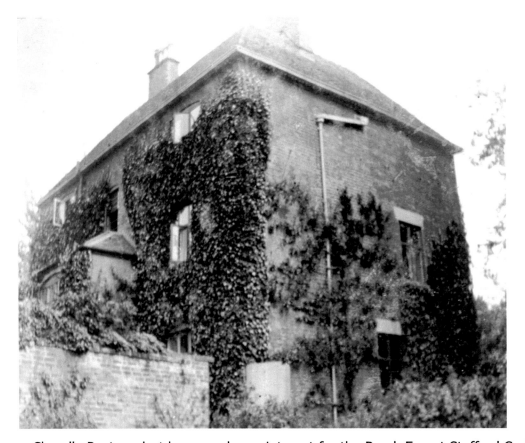

Above: Cheadle Rectory, last home and appointment for the Revd. Ernest Stafford Carlos.

Lastly, taking holy orders was not new in the family. A Norfolk branch of the family included the Revd. James Carlos, son of James Carlos, bookseller of Norwich. He was educated at Norwich, then Cambridge and later ordained in 1748. He progressed from curate through to priest, rector and Chaplain to St. David's. He died at Blofield in 1804. His son, also the Revd. James Carlos, claimed in the *Norwich Mercury* to be the last descendant of Colonel Carlos who was with Charles II in the oak at Boscobel. His last post was Rector of Thorpe by Haddiscoe, Norfolk, 1804 - 1844 (previously Rector of Drinkstone, Suffolk).

MORE ON ERNEST'S SIBLINGS

The Revd. John Buckler was first vicar at Holy Cross Church, Hornchurch, 1926 - 1945. He went on to King's Pyon with Burley, Herefordshire, where he remained until his death in 1951. He had married Maude, but they remained childless.

In 1958, organist Ted was filmed by the BBC at the Priory Church, Leominster, Herefordshire. They were there filming the Harvest Festival service. He and his twin brother Bob were at that time living at Brewood, once home to their Stafford ancestors.

Ernest's only sister, Nina, remained in the family home and supported her mother and the family. Despite having a complete physical breakdown in 1914, when well she continued to support her mother's charitable Childer Chaine organisation. She died in 1955. For both Nina and Ernest's father, John Gregory, there is frustratingly little known about their outside interests and affiliations.

After attending Wilson's School, Arthur Sydney Carlos went on to Birkbeck College. He became a research chemist. He was at one time on the parish council for Hayes. In later life (1950s) he was Public Analyst for first the County of Poole, then the County of Bournemouth. Both a Rotarian and Freemason, he maintained strong links with the Scout movement. He was latterly Scout District Commissioner in Christchurch, Dorset, and was awarded the Silver Acorn. He died on the 17th June 1960 (close to Ernest's 14th June). He had three children: Rosemary, Margaret and Francis (the late Revd. Francis Carlos, after serving as a vicar in Canning Town, East London, ended his official duties as a vicar in Wentnor, Shropshire, a post he held for twenty-nine years).

The Revd. Francis Carlos married June; they produced: Anthony, Robert, Anne and Susan. To date, after Anthony and Robert, there are no other males in the Carlos line.

Announcement of a baby daughter for Sydney and Doris Carlos.

Above: Various plaques by which members of the Carlos family are remembered to this day in the Priory Church, Leominster. It is coincidental that the twins should leave their Bromley home - The Priory, Homesdale Road - for Ted to be organist at the Priory Church. A post he held for twenty-three years.

MORE ON THE BUCKLERS

Some of the earliest Bucklers came from the Isle of Wight. Ernest's great-great-grandfather, John Buckler FSA, was born in Calbourne on the Isle of Wight in 1770, but after leaving school he was articled to Southwark architect and surveyor Mr. Cracklow for seven years. He went on to have numerous children and they, along with some of their off-spring later, worked at the family architect business in Rockingham Row, Newington. The Bucklers at that time resided in Bermondsey's Spa Place, Spa Road.

Photos overleaf: The birthplace and homes for numerous members of the Buckler family. The first is their cottage in Calbourne, Isle of Wight, painted *c.* 1828 by John Buckler FSA. Middle photo shows the Buckler residence in Spa Place, Bermondsey (later demolished). Bottom photo shows the Elephant and Castle, view from Newington Road, 1858.

Cottage in Calbourne

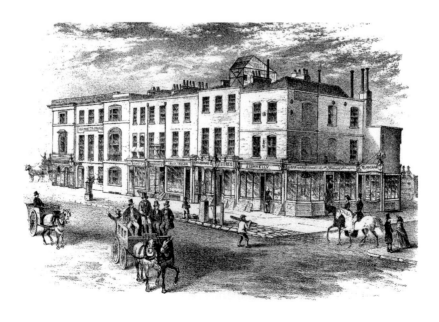

Below: The Revd. William Buckler was born in Bermondsey in November 1809. Ordained in 1833, his last clerical appointment was as vicar of St. Mary Major, Ilchester, Somerset (shown here, along with his grave).

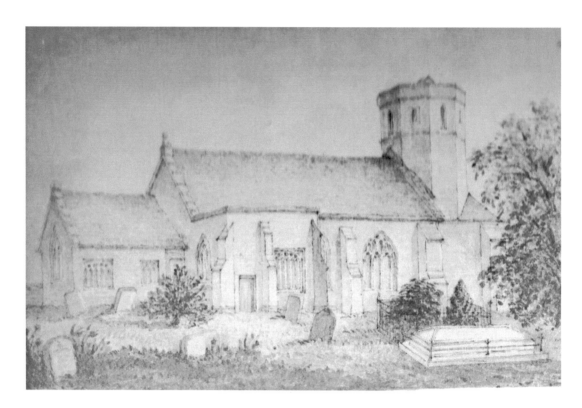

Charles Alban Buckler was the grandson of John Buckler FSA. In 1844 he converted to the Catholic faith. He was a member of the Order of Malta. The architect of the Dominican church near Haverstock Hill, Hampstead, he designed numerous Catholic churches and convents. He was also a Surrey Herald. His son was George Buckler, Ernest's maternal grandfather.

Left: The book written by Ernest's maternal grandfather, George Buckler (who lived close by in Camberwell New Road). George was the son of John Chessell Buckler (1793 - 1894). John Chessell outlived his son; in his early life he had been taught to draw and paint by the watercolour painter Francis Nicholson. Among his many works, John Chessell published *An Historical and Descriptive Account of the royal palace at Eltham* (1828).

Architects, authors and artists, many of the Bucklers were talented men...

One William Buckler (1814 - 1884) was the son of William, brother of John Buckler FSA. William, born at Newport, Isle of Wight, became an entomologist. He was earlier a student at the Royal Academy and went on to exhibit many paintings and watercolours there.

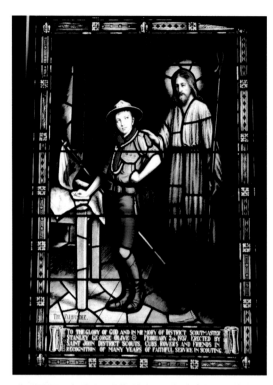

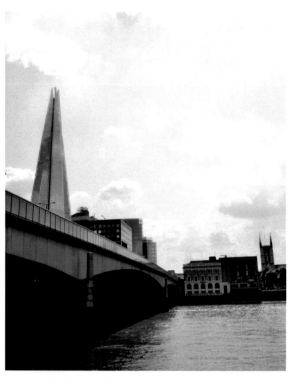

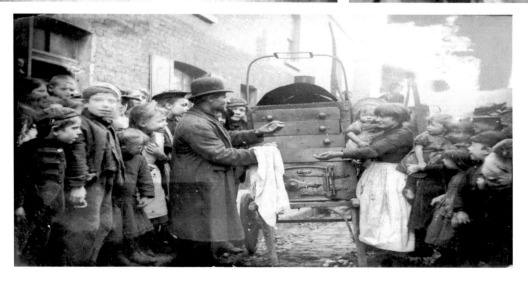

Photos on previous page (left to right): *Pathfinder* window in St. George's and St. Jude's Church, New Brunswick, Canada; London Bridge looking towards South London; female artists of the Royal Academy art schools; Ernest's portrait of Bishop Wordsworth (one time Bishop of Salisbury); a South London takeaway, Victorian style.

ACKNOWLEDGEMENTS

Grateful thanks are here recorded to all the people who gave generously of their time in the making of this book. Particular thanks must go to the Carlos family, and especially to June Carlos. June's late husband was the Revd. Francis Carlos, whose father, Sydney Carlos, was one of Ernest's brothers. Additional thanks are here recorded to: Bear Grylls for writing the foreword; Chris James of The Scout Association for his support and excellent liaising skills; Daniel Scott-Davies and Claire Woodforde of the Scout Association's heritage and archive centre; Paul Lewis MA for contributing an overview and critique of the artist; Michael Loomes, John Roberts and Francis Pigott for reading the typescript and for their useful comments.

Lastly, the following departments, institutions and people were also instrumental in bringing this work to fruition: Ken Mansell, Clifford Jones, Andrea Welstead of Christ's Hospital School and Museum; Sacha Marsac, archivist at Wilson's School; Susan Jack; the British Library; the National Portrait Gallery; the National Army Museum; Professor Sir Alan Craft Kt., MD., FMedSci; Revd. Parsons; Roy Masini; Trinity College Library, Cambridge University; Revd. Nicholas Elder; Law Society Library and Archives; Norman Jackson; Dr. Patricia Dark and Southwark Local Studies Library; Bromley Library and Archives; Lambeth Archives; the Imperial War Museum; the Royal Academy Library and Archives; Royal Hospital Chelsea; Victoria and Albert Museum Library and Archives; Joanna Friel; Joe Correa; John Doble; Father David Pennells, St. John the Divine Church; Father John Davies, St. Saviour's Church, Shanklin; Revd. David Pearson; Revd. Michael Rowlands; Doug Ramsey; Erdington Six Ways Baptist Church; Viscountess St. Davids.

PICTURE CREDITS

Modern street maps on pages 6 and 33 courtesy of Geographers' A-Z Map Co. Ltd.

Page 11: Isaac Fuller painting, National Portrait Gallery.

Southwark Local Studies Library: St. Mary's, page 17; London Bridge, pages 20, 21 and top of page 22. Old maps, page 14. Top and bottom photos on page 67. 'Takeaway' on bottom of page 126.

Christ's Hospital School and Museum: pages 25 and 26.

Wilson's School: page 44 and top of page 45.

London Metropolitan Archives: Choir register, page 79.

Royal Academy Photo Library and Archives: pages 56 and 126.

Pages 90 and 117: National Army Museum.

Page 94, bottom right and top of page 95: James Marpole.

The Scout Association: letters on page 74; *Be Prepared/Headquarters*, page 76; *Pathfinder* on left side of page 83; B-P's letter, page 96; *Good service work in a London slum*, page 107; *Raw Material*, page 128; *A ripping Yarn* (painting on the back cover).

Pathfinder window (St. George's and St. Jude's Church, Canada), page 126: Susan Jack.

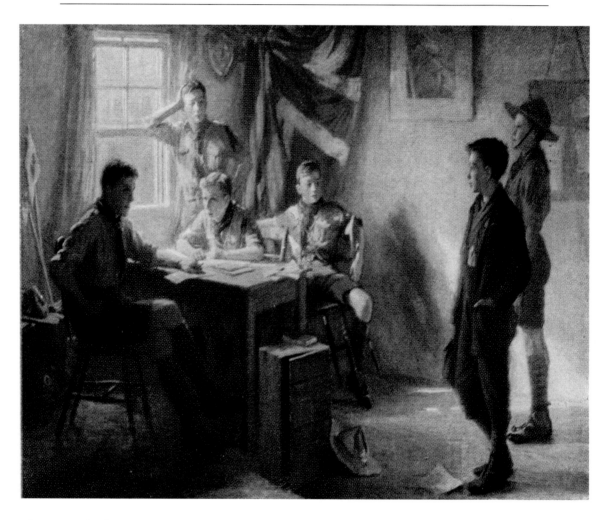

Above: A final image, Ernest's *Raw Material*. Painted *c.* 1915, it depicts a Court of Honour where the new recruit stands before Patrol Leaders in the Troop. It is said to be Scouts of the Wellington Troop with their young Scoutmaster, Maurice Gamon.

Other books by Steven Harris include two titles which come fully illustrated with b/w and colour images: *Baden-Powell's Footprint Across Britain* (Lewarne publishing, 2010)
Baden-Powell Country (Lewarne Publishing, 2011)